WATERLOO, SEAFORTH & LITHERLAND

THROUGH TIME

Hugh Hollinghurst

AMBERLEY PUBLISHING

Acknowledgements

To Albert Howarth, Roger Hull, Peter Owen, Les Thomas and Bill Turpin, who have generously allowed me to use their collections of postcards and other archive material and given me the benefit of their knowledge and experiences.

To the following, who have contributed information and images: Jonathan Cadwallader, the Crosby & District Historical Society, Sam Hardy, Roger Haynes, Tony Hird, Paul Hollinghurst, the Linacre Mission, Brenda Murray, Richard MacDonald, John Quirk, Doreen Samuel, the Sisters of Park House and Geraldine Williams (on behalf of the late Bob Wright).

To the Local History Unit (Crosby Library) of the Sefton Library Service for their help and use of archive photographs on pages 6, 19, 21, 40, 43, 52 and 75; the *Crosby Herald* for images on pages 5 and 43; and the Friends of Waterloo Seafront Gardens for the photograph on page 13.

Other photographs by Hugh Hollinghurst.

To my wife Joan, Crosby born and bred, who has proofread and been a great source of encouragement, information and reminiscences.

First published 2014

Amberley Publishing
The Hill, Stroud, Gloucestershire, GL5 4EP
www.amberley-books.com

Copyright © Hugh Hollinghurst, 2014

The right of Hugh Hollinghurst to be identified as the Author of this work has been asserted in accordance with the Copyrights, Designs and Patents Act 1988.

ISBN 978 1 4456 1510 3 (print)
ISBN 978 1 4456 1519 6 (ebook)

British Library Cataloguing in Publication Data.
A catalogue record for this book is available from the British Library.

Typesetting by Amberley Publishing.
Printed in Great Britain.

Introduction

Waterloo and Seaforth grew up in the early nineteenth century between the ancient townships of Great Crosby and Litherland (recorded in the Domesday Book). From 1856 onwards, a Waterloo-with-Seaforth local district emerged with council offices in Great George's Road, Waterloo. In 1937, it was merged with Great Crosby to form the Borough of Crosby. Finally, in 1974, now part of the North Liverpool conurbation, the area became part of the Metropolitan Borough of Sefton, which stretches from Southport to Bootle. The map below (orientated east) shows the boundaries between them as defined by the Post Office. Waterloo is L22, with Brighton-le-Sands recently asserting its independence between it and Blundellsands. The Leeds Liverpool Canal skirting the Rimrose Valley forms the boundary between Litherland and Seaforth (both L21).

In 1816, a dinner to celebrate the first anniversary of the Battle of Waterloo was held in Crosby Seabank Hotel. Situated in marshland with a fine beach for bathing, it was called the Royal Waterloo Hotel in honour of the occasion and gave its name to the area,

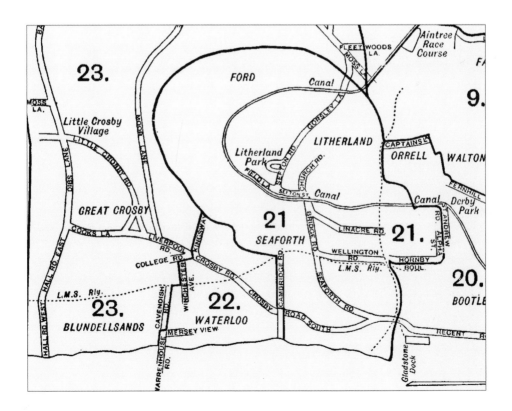

although 'Waterloo' was dropped around 1875. The first in a line of terraces stretching north along the seafront had come in 1815, culminating in Beach Lawn and the house of Thomas Henry Ismay, founder of the White Star Line. In the 1930s, the foreshore in front of the terraces was developed under a scheme to help the unemployed make a series of gardens, and more recently a marina has been created in front of those. Meanwhile in the hinterland a variety of housing had developed, from the grand detached houses of Waterloo Park (surviving, many converted for other uses) through the middle range inter-war suburban expansion (surviving) to the terraces of 'Little Scandinavia' (demolished). The lack of that scourge of local shops, the large supermarket, means that the main retail axis of St John's Road, Crosby Road North and South Road flourishes.

In 1813, John Gladstone, one of the richest merchants in Liverpool, moved from Rodney Street in Liverpool, bought 100 acres of land and built a grand house. He called it Seaforth House as the head of his wife's Scottish clan was Lord Seaforth. His famous son, William Ewart Gladstone, four times Prime Minister, had been born in Rodney Street and spent his early years in Seaforth until moving on to Eton, Oxford and politics. Other rich people were encouraged to follow John Gladstone's example, and several large mansions, each with an art gallery, were built, especially along the shore with fine views of the sea. John built a church for himself and the growing community that serviced the wealthy. A village developed with a fine crescent of Victorian buildings. Railway links to Liverpool encouraged growth and the Overhead Railway brought trippers to Seaforth Sands.

Then, with the spread of the Liverpool conurbation, the grand houses were sold, demolished and their places taken by housing or dock development (although Seaforth still has seven listed buildings). Bowersdale Park is the only relic of one of these. Seaforth was badly affected by bombing during the war, which started an exodus, and post war suffered even more from developers. What precipitated its decline most of all, however, was the opening of the Royal Seaforth Container Dock in 1973. The road to carry the freight traffic to and from the dock brutally bisected the community historically, geographically and socially. In 1984, half of Seaforth went into Sefton Central constituency and half to Bootle. There was little space or appetite for new housing, and a lack of social facilities to replace the cinema and pub. The retail trade has been dealt a final crushing blow by the arrival of a giant supermarket on the doorstep. A memorial fountain to one of its most worthy sons, Superintendent Cross, is largely forgotten, and unused (because it is unusable), but a lift to the area has recently been given by the unveiling in 2013 of the Gladstone memorial.

Since its first mention in the Domesday Book, Litherland was an agricultural community. In the nineteenth century, the advent of the Leeds & Liverpool Canal and the railway network facilitated significant industrial development, including six tanneries, chemical works, matchworks and rubber factories. Their closure has released land for housing with attractive canalside development. Meanwhile, Litherland Park has retained the character of its nineteenth-century businessmen's origins. Like Seaforth, the dual carriageway created to carry container traffic to the dock has divided the community but the revival of the carnival is an encouraging sign of renewal.

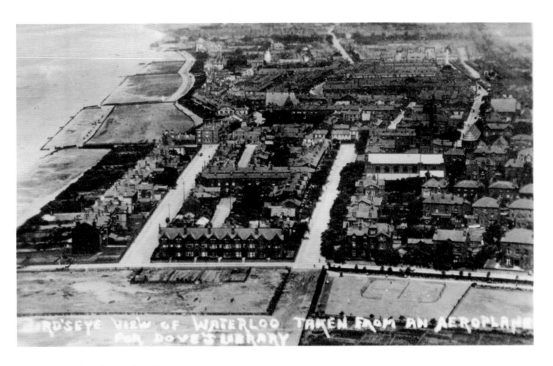

BIRD'SEYE VIEW OF WATERLOO TAKEN FROM AN AEROPLANE FOR DOVE'S LIBRARY

Waterloo from the Air

In the 1934 view looking north, the Marine Gardens can be seen in their embryonic state (*left middle distance*). In the foreground to the right are the gardens of Potters Barn, while the open space to the left has now been taken over by the Seaforth Container Terminal. Between the terminal and the gardens is The Esplanade and the light-coloured roof of Christ Church dominates centre right. Behind is St Thomas's. The modern view, taken from the west, shows how the shore has been developed as a marina, gardens, seafront promenade (*bottom left*), seaport (*centre right*) and nature reserve (*bottom right*).

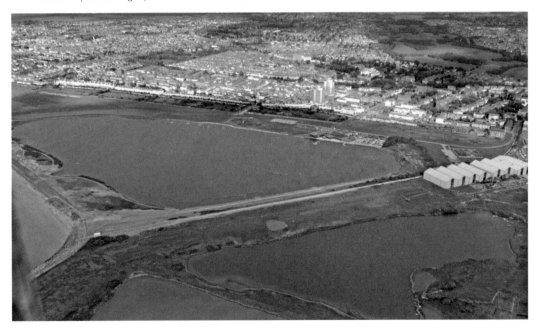

5

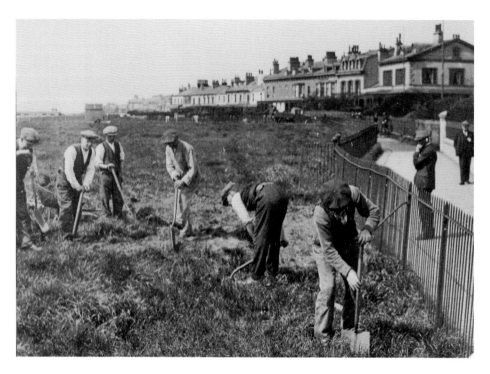

Marine Terrace Garden

A sextet of workers start the daunting task of transforming half a mile of tough grassland into landscaped garden with a spade each and one wheelbarrow between them. A bemused spectator looks on. The foreshore in front of the terraces from Marine to Crescent to Adelaide and Beach Lawn was developed in the 1930s under a scheme to help the unemployed. The path in front of the original Marine Terrace cottages by the Royal Hotel to the right has since been widened and continues in front of the later buildings of Marine Terrace and Marine Crescent.

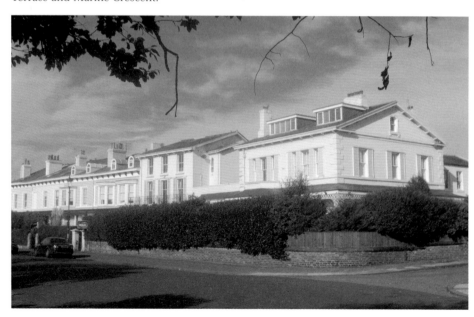

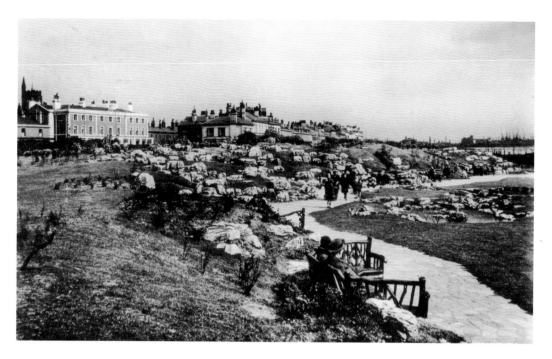

Royal Hotel

In this 1935 shot, taken soon after the gardens were opened, the Royal Hotel appears on the left with the tower of Christ Church behind it. Centre right are the buildings of The Esplanade and to the right in the distance the forest of cranes needed to load and unload the cargo ships of the day. Now a few container lifts, glimpsed to the right of the recent photograph, are sufficient to shift the same amount of tonnage in a fraction of the time.

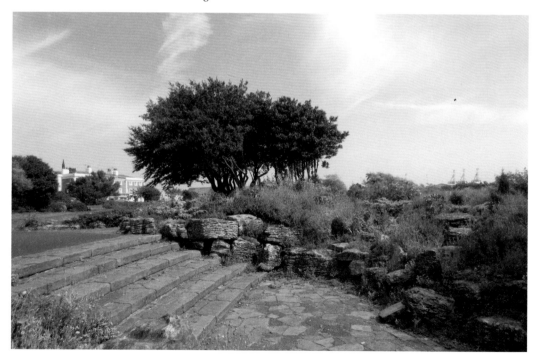

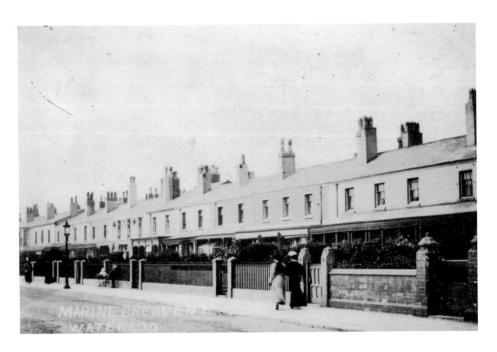

Marine Crescent

John Smith, captain of the *Titanic*, lived at No. 4 and later No. 17 Marine Crescent. In spite of being cleared of any blame for the disaster in the British enquiry, he did make a definite error in not having a fire drill in direct contravention of White Star policy. Although this was not against the law, the failure must have contributed to the loss of life. No. 17 sports a blue plaque in recognition of him.

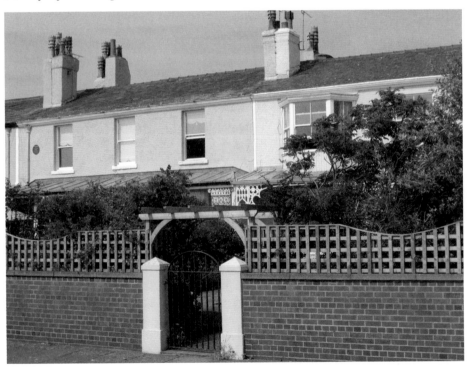

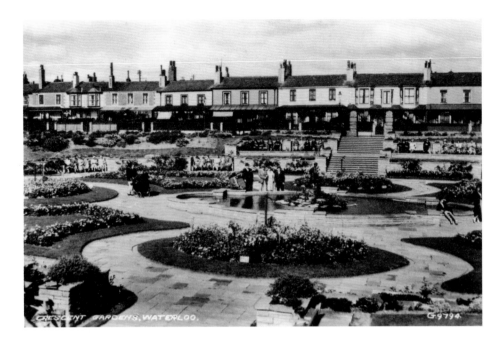

Crescent Gardens

The vantage point of the photographer, every seat bar one being packed with people, the balance of ladies with prams, the exaggerated gesture of the lady in the latest fashion looking out to sea and a standing group forming the focal point all hint at a special posed occasion, maybe to record the opening. The colour of the roses have to be imagined as there is no trace of them today in the sadly run-down garden. However, the Friends of Waterloo Seafront Gardens are valiantly attempting restoration.

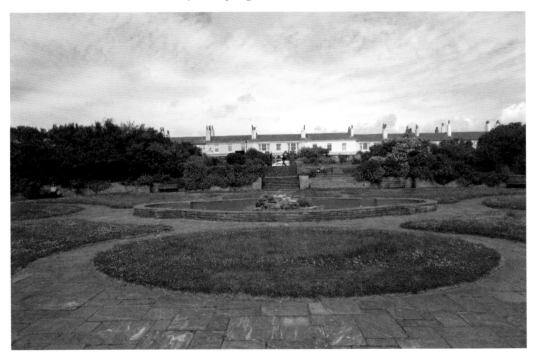

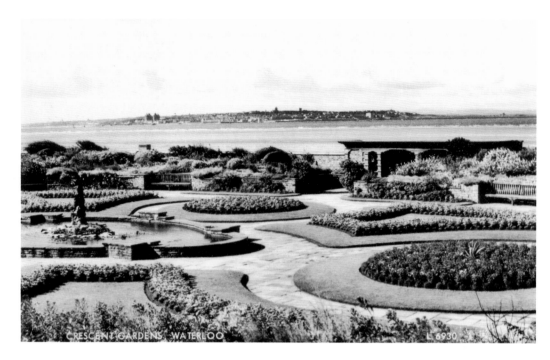

Crescent and Adelaide Gardens

The distinctive outline of New Brighton can still be seen across the Mersey with the Welsh hills visible on the right, apart from the disappearance of the base of the New Brighton Tower. The tower was dismantled in 1921 but the ballroom in its base remained in use until destroyed by fire in 1969. The foreshore has been dramatically altered by the development of the Marina, Seaforth Container Terminal, Radar Tower and wind turbines. However, you can still see two churches on the Wirral silhouetted against the sky and the summer house on the right.

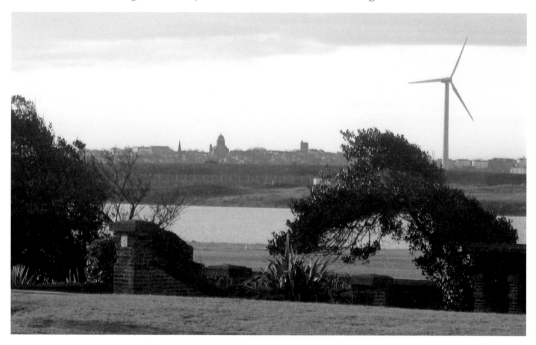

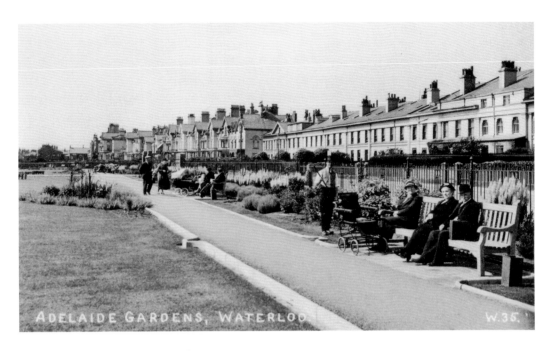

Adelaide Terrace and Beach Lawn

Old and young alike enjoy being wheeled out to enjoy Adelaide Gardens in front of the terrace. Further along at the end of the next block, Beach Lawn, commemorated by a blue plaque, was the home of Thomas Ismay and his son Joseph Bruce Ismay. Born in Crosby in 1862, Bruce became managing director of the White Star Line, which owned the *Titanic*, and the White Star ships would salute as they passed the residence. He sailed on the last voyage of *Titanic* and was rescued after leaving on one of the last lifeboats.

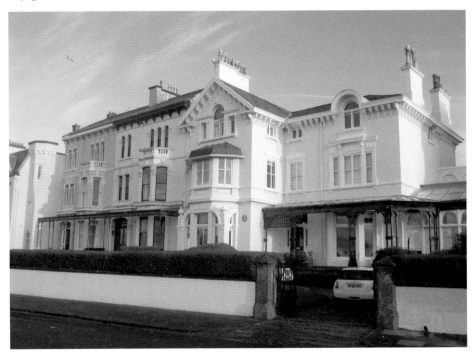

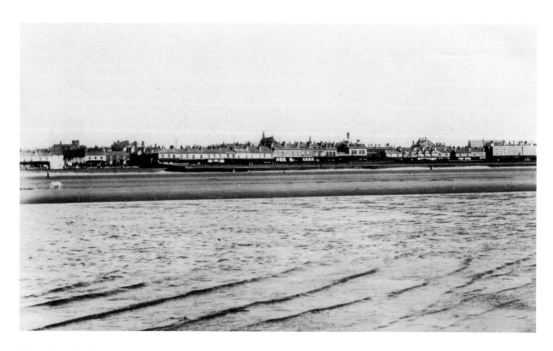

Waterloo Seafront

The photographer must have got his feet wet taking this panorama with Marine Terrace in the centre, the Wesleyan Methodist church behind it in the centre and on the right the cottages of the terrace beside the Royal Hotel, with St Thomas' church behind them. A similar vantage point today (on the edge of Seaforth Dock) continues the panorama to the left, ending in Beach Lawn, and shows how the foreshore has been transformed by the creation of a marina. The tower of St Edmund's to the left and right respectively shows how the two panoramas fit together.

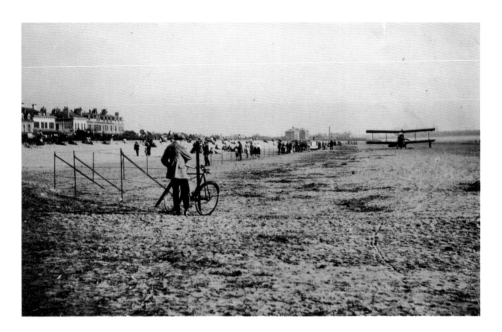

Henry Melly

The aviation pioneer Henry Melly spent his honeymoon learning to fly at the Bleriot School of Aviation in 1910, only seven years after the first flight of the Wright brothers. Settling in Crosby, he immediately set up the *Liverpool School of Aviation* on the shore at the bottom of Sandheys Road with his Bleriot aeroplanes, two hangars and a workshop. The following year, he recorded a double first – a complete circuit of Liverpool, and Liverpool to Manchester and back, winning a prize of £1,000 (equivalent to £100,000 today). The landing strip seems to occupy the area between the end of The Esplanade through to Seaforth Hall (*centre of the photograph in the distance*). Today, this area is covered by the Seaforth Container Dock. One of its vast transit sheds has been decorated with iconic images of the area: the Overhead Railway, the *Titanic*, the Crosby windmill, the Five Lamps and the Crosby to Seaforth tram.

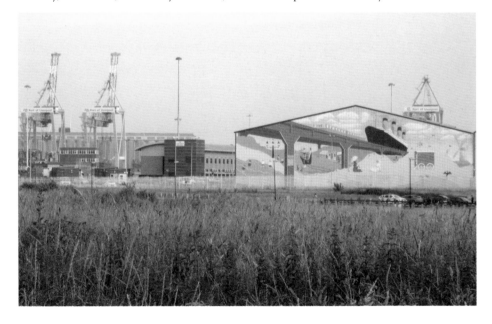

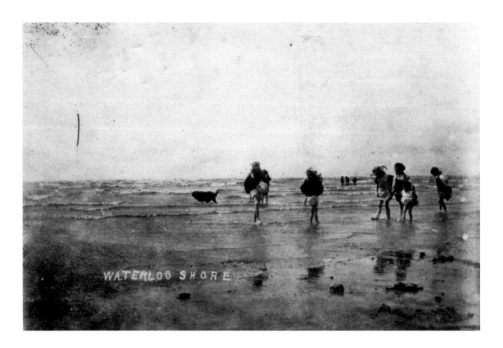

Shore

In the past, you had a long way to go to get into deep water so these girls and their dog are content to paddle on the edge. Besides, you might spoil your best clothes! Reflections in the pool and the remains of sandcastles complete the 1902 picture of the beach at Waterloo. The sea is far out in 1926 so all ages from baby to fashionable lady indulge in sand play, with hand or spade and a bucket for the sandcastles. Judging by the clothing, the weather was not conducive to bathing, although there is no sign of protection from the elements. The gardens had yet to be created.

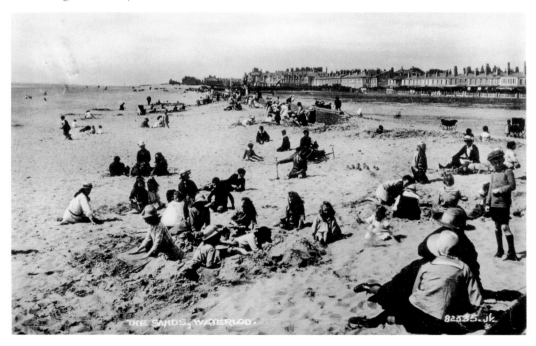

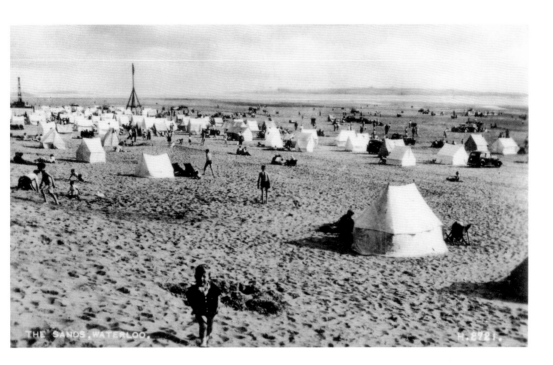

THE SANDS, WATERLOO. H.2721.

Sand

The reverse of the card sent in August in the 1940s says, 'Having a very nice time. Weather not too good. I spent two afternoons on these sands so far & going again if rain holds off.' The tents may have been useful for rain as well as sun, but for the moment many bathers are happy to enjoy the warmth of the evening sun as the shadows lengthen. Most of them are on Blundellsands, as Brighton-le-Sands and Waterloo start beyond the mile marker. Today, people on an evening stroll on the beach mix almost indistinguishably with the iron men.

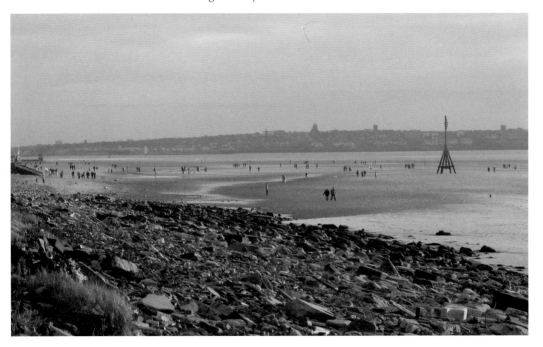

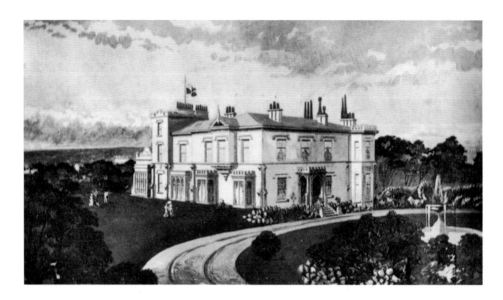

Sandheys

This palatial building was the home of Richard Houghton, a timber merchant wealthy enough to donate five magnificent Capronnier windows in St Luke's church to commemorate his family, and finally himself. Spread over 14 acres with four lodges, it was the third highest rated house in the area and Richard was referred to as 'Squire Houghton'. On his death in 1875, Sandheys became Waterloo High School, with additions and alterations. It was later demolished and over 100 dwellings built on the estate, including Gordon Avenue, so-called after his wife's family. In contrast, a present-day view on Crosby Road North shows offices created from a large, redundant residence and work in progress on conversion of the Welsh Presbyterian church to living accommodation.

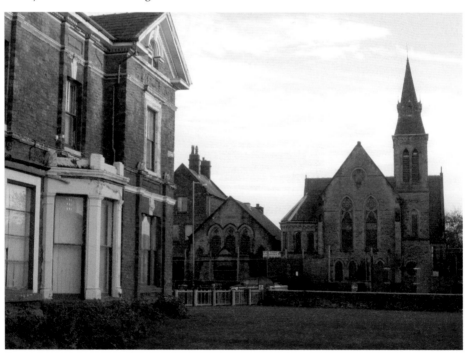

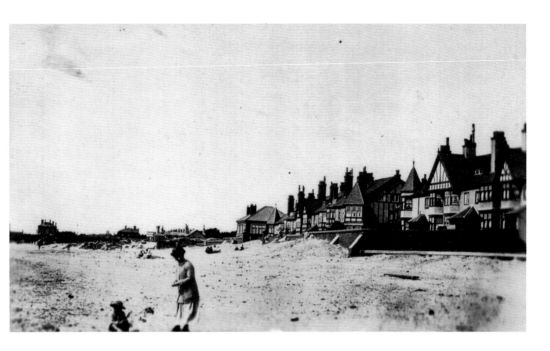

Beach Bank

The lady, child and dog may have walked straight on to the beach from Beach Bank or from Oxford Drive, which comes down to the shore between the two houses with the corner turrets. These, with their French chateau roofs, are a distinctive feature of corner houses in the area built at the time, and like so many have been spoilt by alterations: on the left by new windows, two panels instead of three, and on the right by a rebuild of the turret roof. However, they still give superb views up and down the river. Remains of the anti-tank pyramids ('dragon's teeth') can be found in the pavement at the end of the road (*inset*).

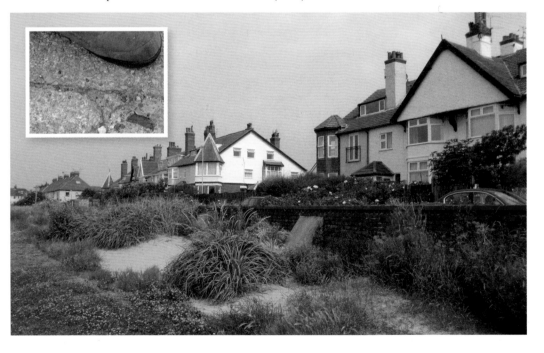

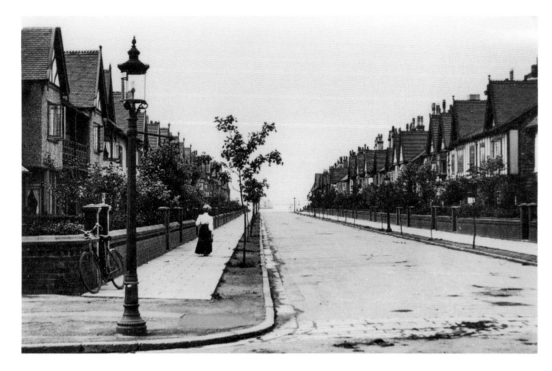

Oxford Drive

Great care has been expended on the composition of the scene: the well-dressed lady walking away from her bicycle, the beautifully proportioned lamp post, the young tree and the sailing ship passing by. How the tree has grown! Now the sea defences prevent the view of any ship and cars have taken over most of the road. The houses seem to be repetitive, but in fact each detached block is different from the rest.

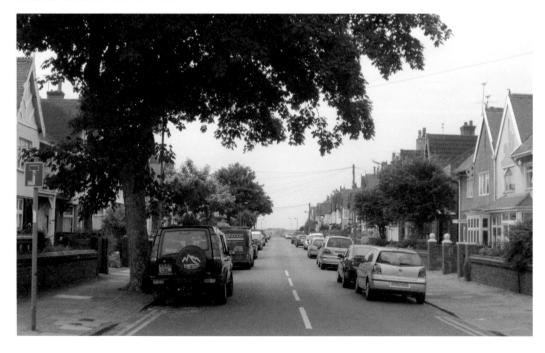

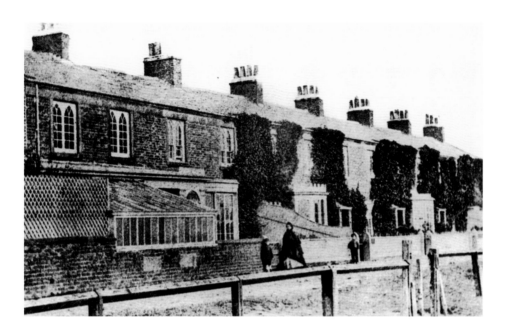

Mersey View Cottages

When the cottages were built in 1822/23 as North Marine Terrace, there really was a view of the Mersey, as no houses on the other side spoilt the scene, and donkeys could be seen grazing on the green. They are distinguished by their large bays downstairs and Gothic windows above. No. 10 even has its original Georgian sashes (*below left*). The date 1823 is visible on a drainpipe on the north end of the block (*inset*). Also appropriately known as Ivy Cottages, they became Mersey View around 1867, roughly when the photograph was taken. Further along, and built slightly earlier, Brighton Cottages are of a superior specification, with three bays each.

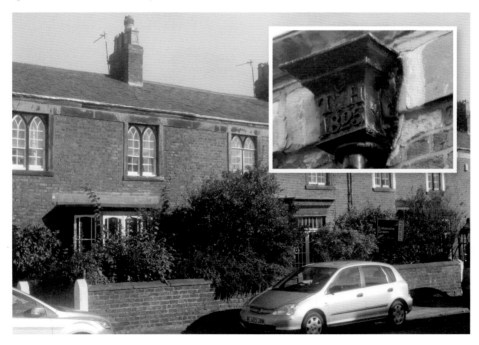

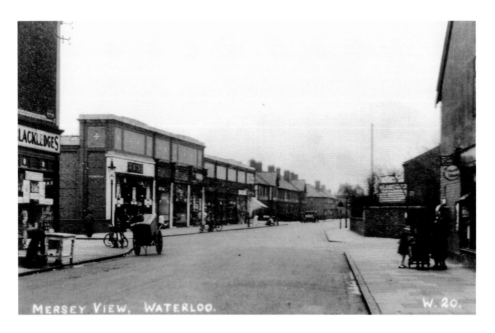

Mersey View

On opposite sides of Brooke Road West stand two complementary stores, part of Merseyside chains that supplied basic foods. Left of centre is still preserved the beautiful façade of the upper storey of Irwin's grocer's (a group taken over by Tesco in 1961 and since dismantled). They always sported interesting shop-fronts and had over 100 outlets. Blackledge's bakers on the left boasted over ninety shops in the Liverpool area at the height of their popularity. Now both have been converted into business premises. Nearby was another purveyor of a basic commodity, Ross's greengrocer's. Once household Merseyside names, they are now remembered only by older generations.

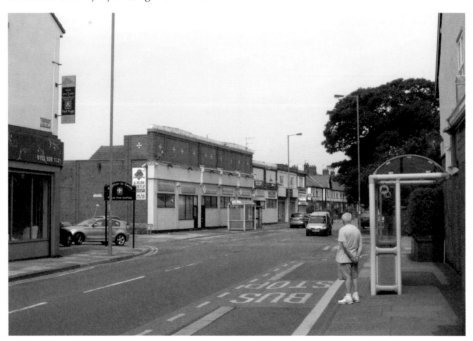

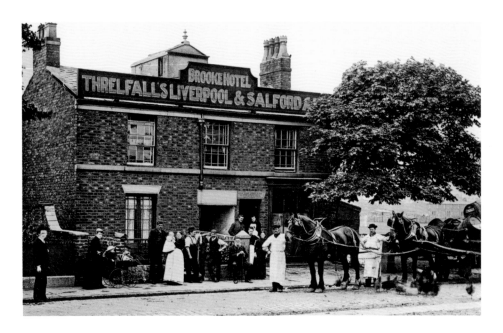

Brooke Hotel

Three generations at least are depicted in front of the old Brooke Hotel. Hens betoken a time when farmland still lay round; Rose Farm Dairy survived until recent memory. A previous pub on the site, Clarke's, was a centre for coursing rabbits. The Brooke's replacement, built in 1922 and photographed not long after, has scarcely changed today. 'Brighton-le-Sands' first emerged in the mid-nineteenth century to denote the area between Brooke Road and Warren House Road. Following local feeling and opinion expressed recently, the name has been reinforced by road signs on Mersey View (as in the recent photograph on the previous page) and Bridge Road.

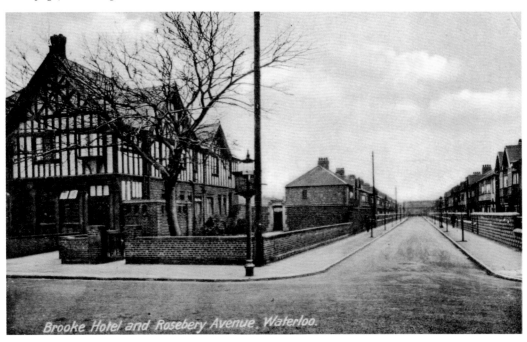

Brooke Hotel and Rosebery Avenue. Waterloo.

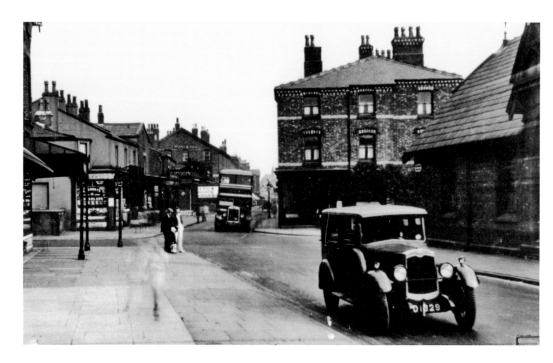

Mount Pleasant

No wonder Mount Pleasant, the most direct route through from Blundellsands to Waterloo, was widened! To achieve this, the handsome building on the right had to be truncated in 1932, losing its first set of windows and corresponding roof. St John's School, the corner of which can be seen on the far right, has escaped, but the two corner shops and arcade have disappeared. Is the beflannelled gentleman or maybe the photographer the owner of the car? The bus is a Leyland Titan on route B, retitled L3 in 1935.

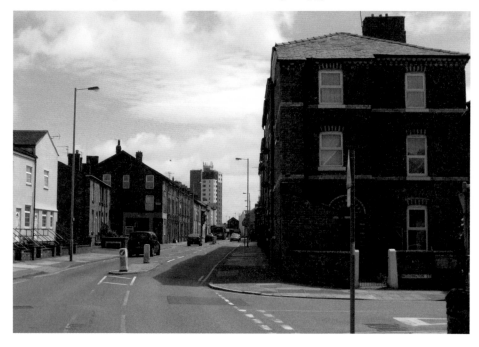

Battle of Waterloo Remembered

Wellington (formerly East) Street is one of four connected streets that commemorate the Battle of Waterloo. Picton Cottage (*below left*), dating from 1851, was named after Wellington's general Sir Thomas Picton who died at the battle. The road further up to the left is named after him, but Murat Street, whose sign is affixed to the cottage, is inappropriately named after Napoleon's general and brother-in-law (who did not take part in the battle but lost his throne in Naples as a result). Both these roads are crossed further down by a street called Blucher, after the Prussian general who arrived late in the day to swing the battle decisively in favour of Wellington.

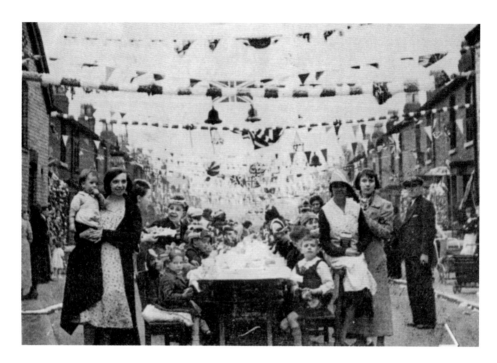

Little Scandinavia Celebration

Norway, Sweden and Denmark Street, originally called the colonies (like those in Edinburgh), formed Little Scandinavia. Sandwiched between the railway line and Oxford Road, and leading off St John's Road, they had a strong local identity. A street party in honour of the 1937 Coronation anticipates the Sweden Street celebration of 1953. There was great competition between the streets to create the best show. The tenements were of typical late-nineteenth-century design, with two living rooms downstairs and two bedrooms upstairs, along with a kitchen added on and an outside toilet.

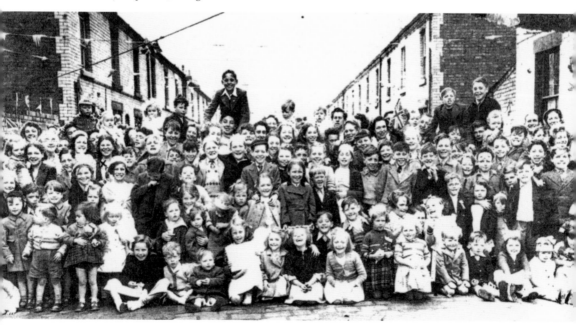

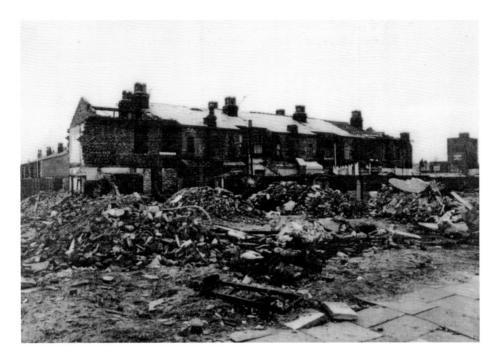

Little Scandinavia Demolition

The demolition scene shows one side of Norway Street, already rubble, and the back of Sweden Street about to meet the same fate. The washing hanging out to dry belongs to a family determined to delay the inevitable and stay until the bitter end. Only the refurbished terraces of Sweden Grove remain, demonstrating how refurbishment, rather than demolition, can work. Beyond them can be seen the new St John's School, built on the end of the streets of Little Scandinavia.

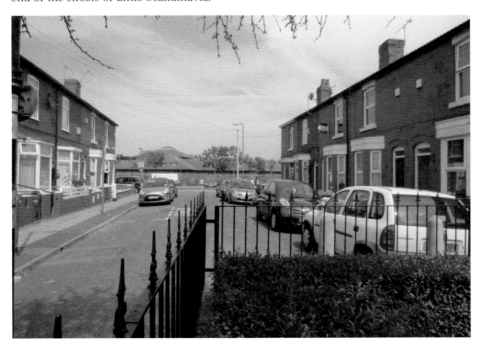

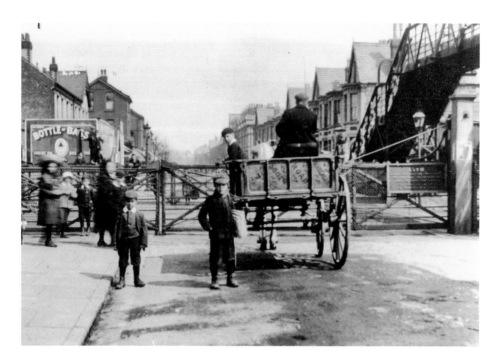

St John's Road Crossing

Those were the days, when boys did a man's work and dressed like men! The horse and driver of the cart wait patiently for the passing of the train, possibly steam hauled, as the line was electrified in 1904, the first main-line electrification in the country. The advertisement hoarding, street lamps and bridge have long since gone, together with the gates and warning notice headed L&YR (Lancashire & Yorkshire Railway, which lost its identity in 1922). However, the buildings are largely unchanged, complete with finials above the gables.

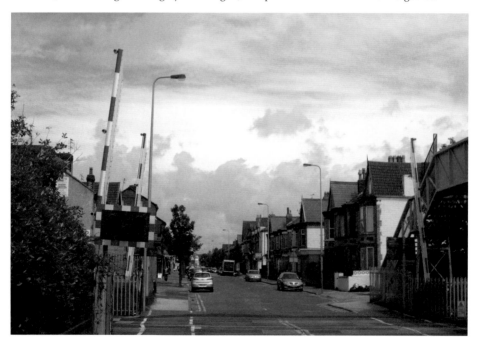

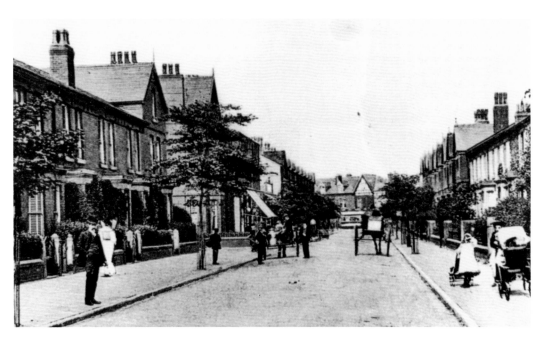

St John's Road

A passing tram points to a moment between 1900 and 1925 when people were able to stand in the road and were free to stand and stare. On the left, the onward march of conversion of residential accommodation to shops has continued to the detriment of gardens, but on the right the houses and gardens remain unchanged. Have some of the trees survived to reach maturity? There is still an awning over one of the shops and above them can be seen relics of the original dormer windows and gables. The railings on the right have gone, replaced by brick walls, and the gardens have been reduced, though the gateposts have survived.

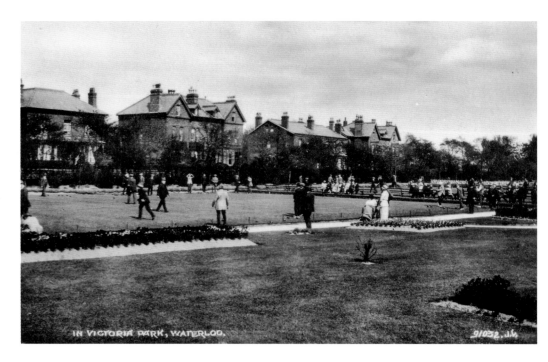

Victoria Park

Gone now is this scene alongside College Road of elegantly attired bowlers in boaters and jackets while spectators look on admiringly. Now, the grass grows too long for such sport and the area is fenced off, but the Friends of Victoria Park are working hard to make improvements. The clubhouse and relic of the floral clock survive but the flowerbeds with their blaze of colour have largely disappeared.

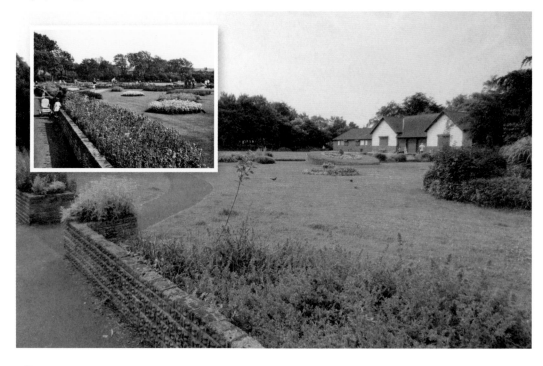

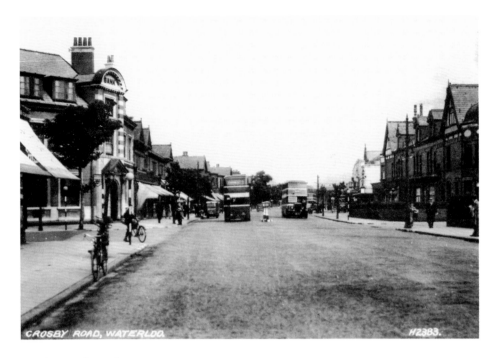

Crosby Road North

Bicycles and buses predominate in a pre-war view of Crosby Road North. The imposing classical façade of the bank (now financial services) remains, but the milk float on the wrong side of the road and lack of road markings are in complete contrast to today's regimentation. Cameron's garage, now Tesco Express, is on the right and beyond it was a little roundabout, now replaced by lights since it was unable to cope with the increase in traffic.

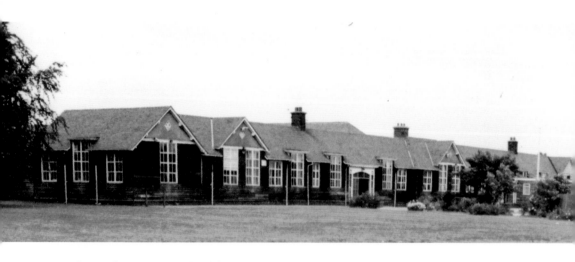

Waterloo Park Grammar School for Girls

They built well in those days! Waterloo Park Grammar School for Girls was opened in 'semi-permanent' wooden accommodation in 1921. It had just celebrated its golden anniversary when it became the home of the first two years of Chesterfield High School pupils before they transferred to the school's main site on Chesterfield Road. The building survived as the annexe until the school was brought onto one site there in 1996, financed by the sale of the land for new housing. The inset shows a Waterloo Park girl standing on her hands by the school fields with Glenwyllin Road in the background.

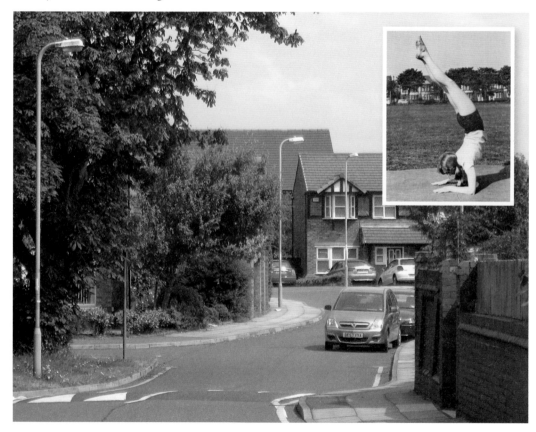

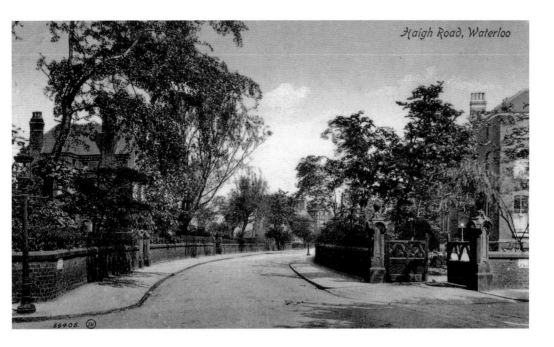

Haigh Road, Waterloo

59406. ⓥ

Haigh Road

The ornamental lamp post on the left and the handsome gates and gateposts on the right appropriately frame this stretch of Haigh Road. Many of the grand houses have survived (see the finial peeping out from behind the tree on the left, *below*), perhaps converted into apartments, with their gateposts intact. Replacement blocks may also have kept theirs like the one on the left. Trees have reached full maturity and the house on the right has been demolished, along with its imposing entrance, to make way for a hospital. The driveway would have caused complications at what is now a busy junction.

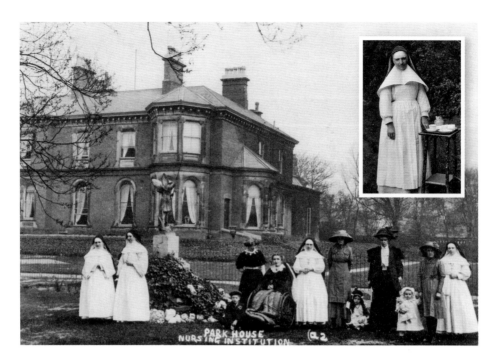

Park House Gardens

Sisters, a patient, visitors and dolls pose in the gardens of the Park House Nursing Institution. The statue of St Michael and All Angels has since been moved to the corner of the garden. Originally built as a merchant's house as part of the Waterloo estate, the house was run as a school until the Augustinian Sisters of the Mercy of Jesus came from Guingamp in France to open a convalescent and residential home for ladies in 1902. The inset shows the Revd Mother Marie de St Andre of Guingamp, foundress of Park House, in her working dress.

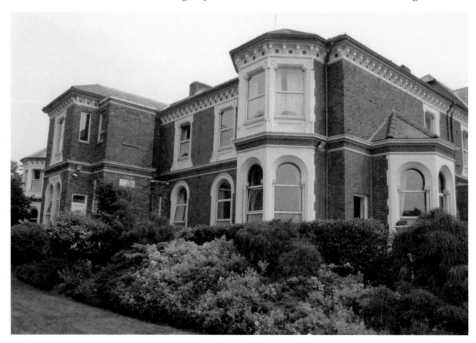

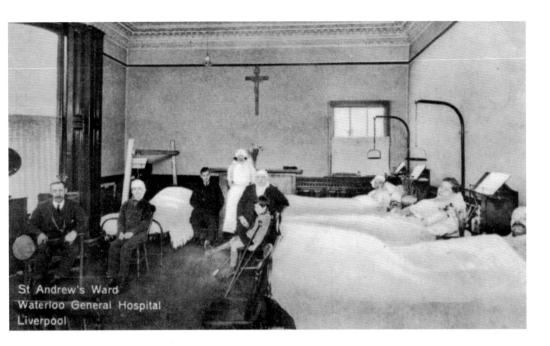

St Andrew's Ward
Waterloo General Hospital
Liverpool

Park House

A very mixed ward in the Waterloo General Hospital! In 1910, Hatherley, a large house, had been adapted as a hospital, Hotel de Dieu, and this was extended in 1923 to form the General Hospital, and both run by the sisters. In 1934, they withdrew from the hospital and Park House was extended to include a maternity department and surgical unit. In 1967, a modern surgical and medical wing was opened. By 1976, the maternity unit had closed and the care of the elderly ceased in 1999. It was then refurbished and modernised as a guest house. Woodbury over the road was destroyed during the May blitz of 1941, amazingly without loss of life.

PARK HOUSE NURSING HOME,

WATERLOO NEAR LIVERPOOL.

TELEPHONE 575 WATERLOO.

MEDICAL. SURGICAL. MATERNITY.

CASES RECEIVED.

TERMS FROM £3:3:0 PER WEEK.

"WOODBURY"

HOUSE OF RESIDENCE FOR LADIES.

CONVALESCENT. HOLIDAY AND PERMANENT

TERMS FROM £2:2:0 PER WEEK.

APPLY REVEREND MOTHER, AUGUSTINIAN SISTERS.

Liver Hotel: Before...

Before the trams' arrival in 1900, beer, maybe from Thorougood's Brewery next to the Town Hall in Church Road, is unloaded at the Liver Hotel. The provider of horse power observes an Aveling-Porter roller powered by steam. During the American Civil War, James Dunwoody Bulloch volunteered his services as a secret foreign representative in Liverpool and took lodgings at the 'Liver Inn' in Waterloo. He then leased a Marine Terrace house, where he arranged and co-ordinated the building of the famous CSS *Alabama*, a secret American Confederate military ship built in Birkenhead to prey on Union shipping.

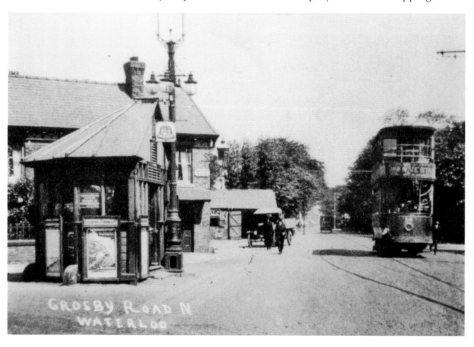

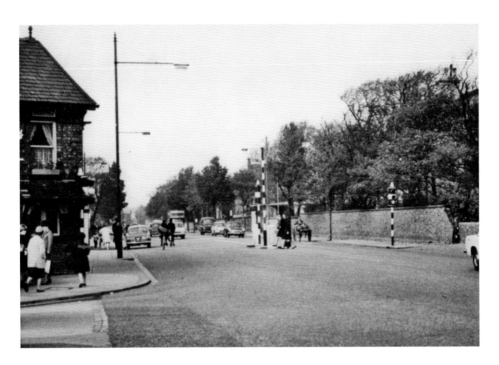

...And After

A 1953 view shows further developments in the road scene. A handcart and bicycles are still in use, but there is more evidence of private cars. The absence of road markings is significant, allowing a car to park on what is now a prohibited area. The smithy, the long, low building behind the Liver in the photographs on the previous page, has gone. It first appears in Gore's Directory of 1876 and continued in business under different owners until the 1940s.

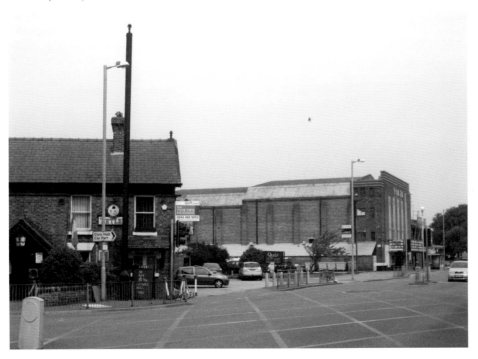

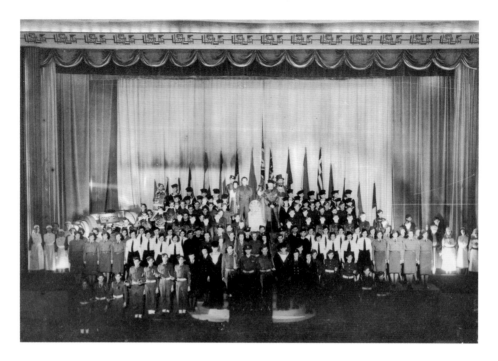

Plaza Cinema

Representatives of youth organisations pose at a service held in the cinema to celebrate the end of the Second World War. The cinema had gained the distinction of opening and closing on the same day (on the eve of the war, 2 September 1939) but reopened a few weeks later. It had a magnificent organ and proscenium theatre arch, the latter preserved thanks to a band of volunteers who run the cinema, the only one in the Crosby area and now again called the Plaza. In between, it has been known as the Odeon, the Classic, the Cannon and the Apollo!

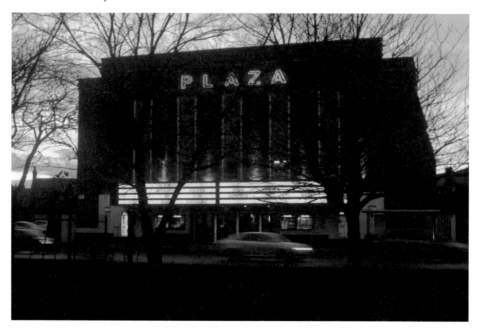

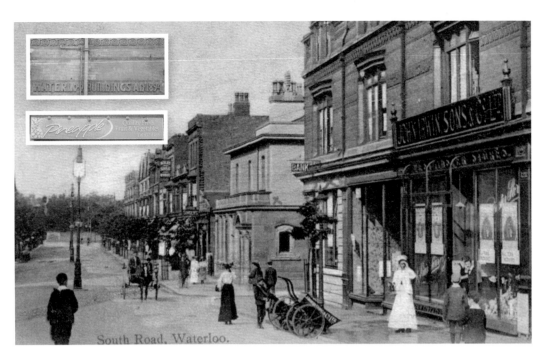

South Road, Waterloo.

South Road Pre-Car

In 1906, the electric standards installed in the centre of the road were not a hindrance to the passing traffic. The elegance of the shop-front on the right, its brickwork (including the building plaque shown in the top inset) and its name (John Irwin Sons & Co. Ltd) complements the ladies' fashions, which are more like evening or wedding dresses, and contrasts with the modern styling of the same premises (*lower inset*). By 1918, traffic had increased, as the later photograph (taken looking the other way) demonstrates. The electric lighting had been replaced by gas lamps on the pavements in 1908 but one lamp post of the old-style lighting can be seen outside the station canopy.

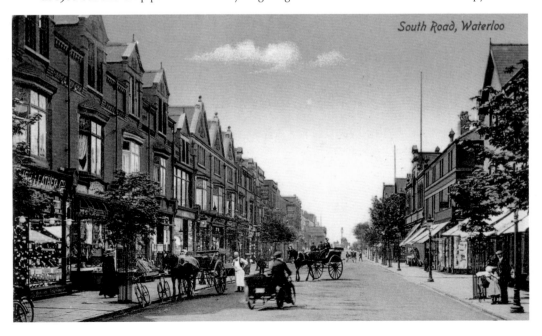

South Road, Waterloo

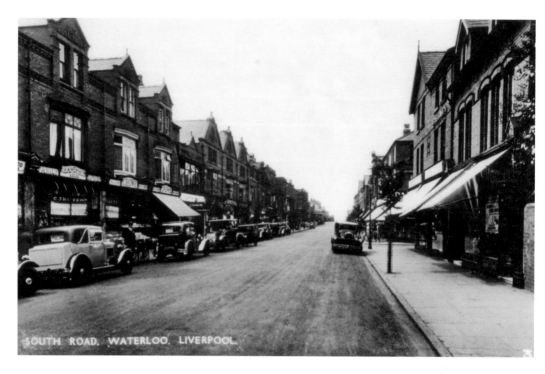

South Road Post-Car

There is even a Rolls Royce in the impressive line-up of cars for shoppers in South Road between the wars. The buildings remain but the shop-fronts, together with their trade, have changed. The decoration of Cremona Corner indicates its origins as a music shop, taking its name from the home town of Stradivarius in Italy.

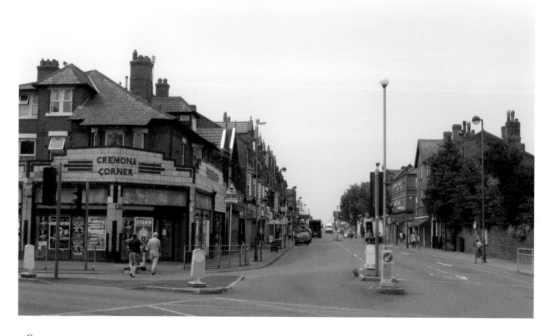

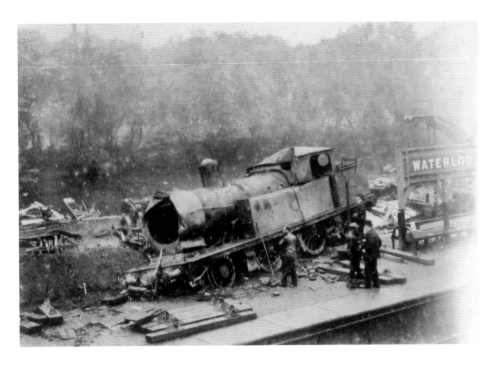

Waterloo Station

Six people were killed in this accident on 15 July 1903. The steam-hauled express train jumped the rails on the sharp curve approaching the station. The line was electrified the following year, but the year after that a worse disaster occurred at Hall Road, two stations down the line, in which twenty people were killed. The magnificent canopy overlooking South Road has survived to this day.

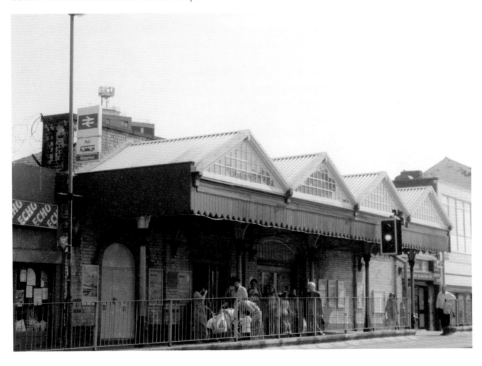

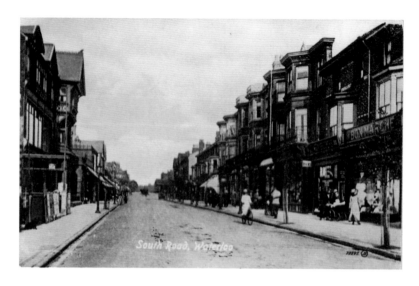

Queen's Picture House

A lone cyclist is the only traffic in Edwardian South Road, although there is evidence of recent horse-drawn vehicles and it would seem that there is a parking place for cabs by the station at the top of the road. Later, beyond the half-timbered building on the left, was the Queen's Picture House, the first purpose-built cinema in Waterloo and Seaforth, opened in 1913. After closure in 1959, it became Waterloo Furnishings, and now Wetherspoon's The Queen's Picture House.

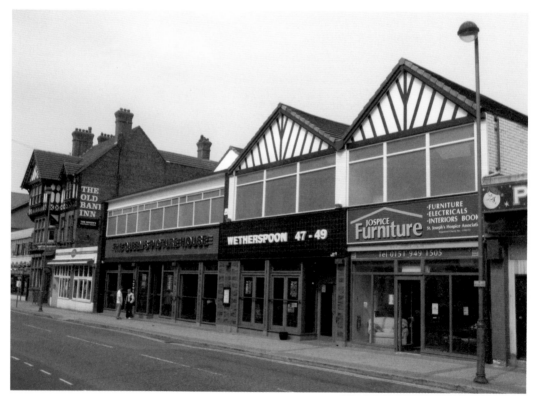

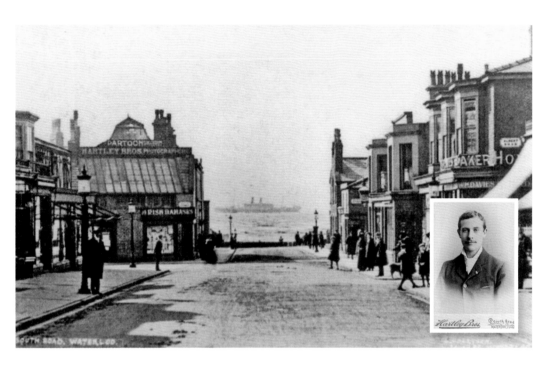

South Road by the Shore

South of what? Originally South Street, the road was south of North Street, now Wellington Street, and joined to it by East Street (to the right, beyond The Marine). There was no corresponding West Street, which would have been Marine Crescent or on the shore! Photographer and postcard producer A. W. Partoon took the picture of his own well-lit premises (*above*), 'successor to Hartley Bros'. All this has been swept away but the mock half-timbering has stayed on the left and on the right The Marine (formerly the Bath Hotel) received an art deco facelift in the 1930s.

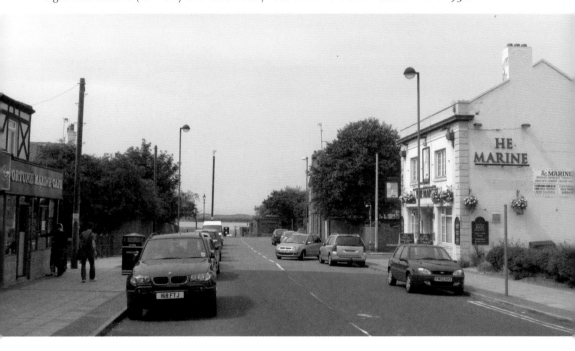

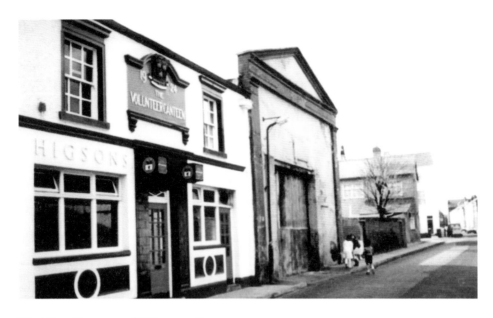

The Bijou Theatre and Volunteer Canteen

Children play outside the remains of the Bijou Theatre. Originally built in 1840 as a Methodist chapel, by 1900 it was the Headquarters of the Salvation Army. During the Boer War (1899–1902) it appears to have been used by volunteers as a drill hall, using the pub next door as their canteen, hence its name (1924 on the front refers to a facelift). In 1909, the Bijou was converted into a theatre when animations were shown interspersed with variety acts. It was known at different times as the Bijou Electric Picture Palace, New Pavilion Theatre and Palace Music Hall until closure in 1922. After a spell as premises for a taxi cab firm and then a motorcycle repair business, it was demolished in the late 1980s and redeveloped for housing.

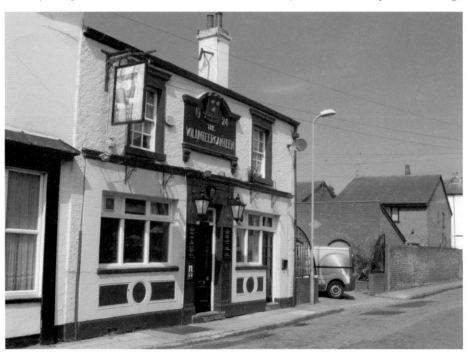

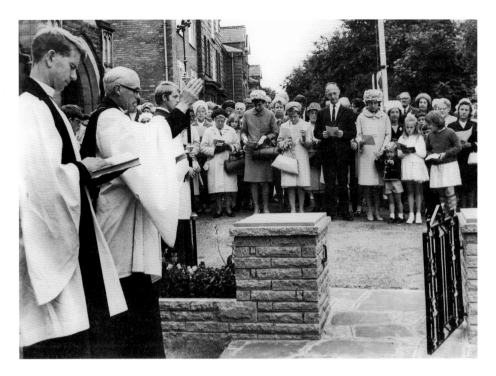

St Mary the Virgin

Revd Charles Pennel in the act of blessing the Garden of Remembrance at the dedication service in 1969 with a crowd of (mostly) attentive worshippers. An iron church was erected in 1877 as part of St John's parish, replaced in brick in 1882. It became a separate parish in 1901 when the hall was built. The church became the first in Waterloo to have electric lighting. In 1936, a new altar was presented, with woodwork carved by 'mouseman' Robert Thompson, whose three mice can be seen today. The entrance to the garden is on the right of the tree in the recent photograph.

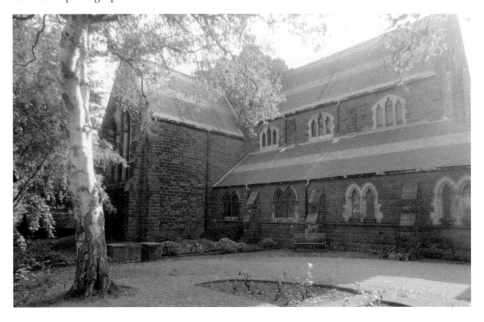

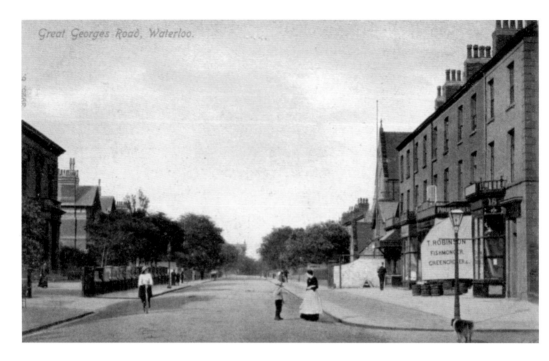

Great Georges Road, Waterloo.

Great Georges Road

Only the dog seems to obey the rules of the road! The spacious thoroughfare lives up to its name, with the town hall on the left and St Thomas of Canterbury on the right. The church was built in 1877 on the site of the first Roman Catholic chapel in the area, opened in 1868. The adjoining Christ Church National School, dating from 1842 (see inset of the plaque, which still remains in situ), was moved to a new building off Crosby Road South, which has since been demolished. The original school building is now a community centre.

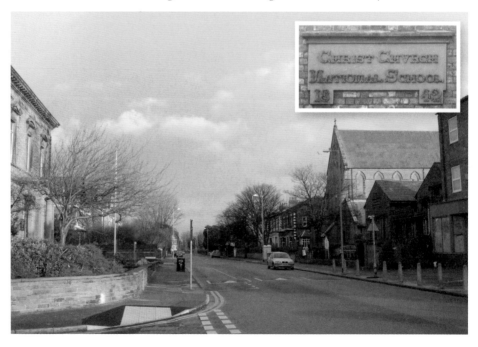

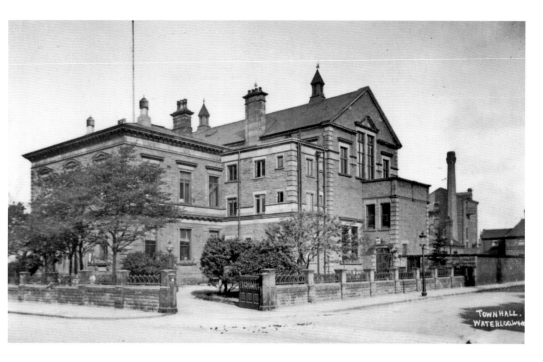

Waterloo Town Hall

Thorougood's 'Lion' brewery on the right was a big establishment. When it was closed, the library and police station were constructed on the site. When they were bombed, the new Central Library was built on Crosby Road North. In 1856, the district of Waterloo-with-Seaforth was carved out of Litherland and council offices were built in 1861. These were reconstructed and enlarged to become the town hall in 1894 and the council was combined with Great Crosby to form the Borough of Crosby in 1937.

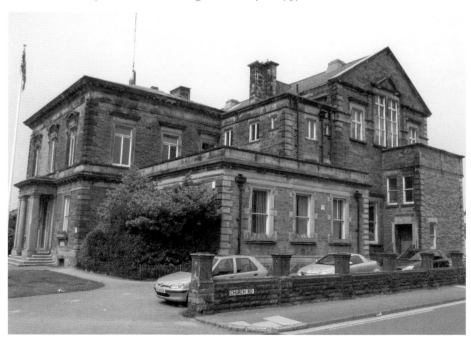

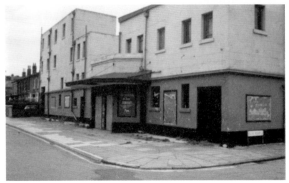

Church Road Winter Gardens

This building dates back to the 1870s and was used as a gymnasium before a brief career as a billiard hall. It opened as the area's first cinema in 1909, known as the New Picture Hall. Rechristened as the Winter Gardens and then the Waterloo Picture Playhouse, it offered variety turns and boasted a Viennese orchestra under the baton of a Herr Weingarten. It was rebuilt and reopened as the Winter Gardens Theatre in 1922, but reverted to showing films in 1931. In later years, it enjoyed the distinction of being the last privately owned cinema on Merseyside. A view of the cinema in its heyday contrasts with one after closure, when it was used as a bingo hall. Since 1983, it has been the home of the Kingsway Christian Fellowship Centre (*below*).

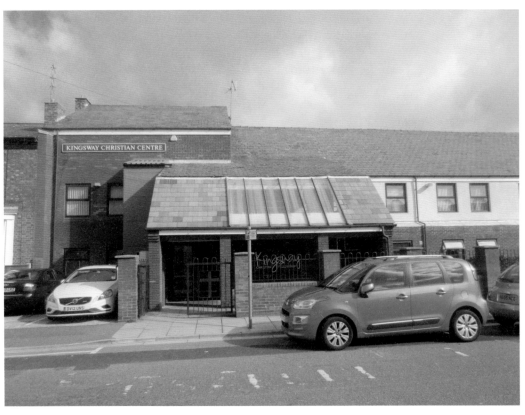

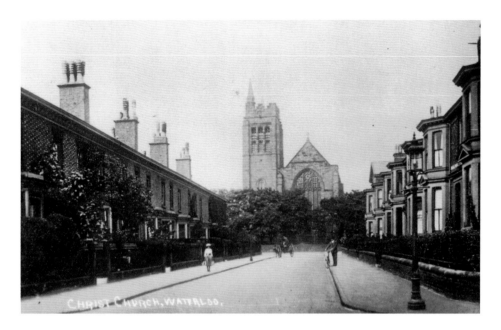

Christ Church

Outwardly, the scene has hardly changed in a century, but Christ Church has experienced great change inside. The original church, the first in the new township and modelled on St Thomas's in Seaforth, was built in 1840. Owing to the ravages of ivy, it was rebuilt on a grand scale in the 1890s and became a landmark for sailors returning to Liverpool, but a dwindling congregation and the increasing cost of maintenance led to its deconsecration. In 1999, the Friends of Christ Church resurrected the interior of the Grade II* listed building (the only one in the area) and established it as a centre for the community.

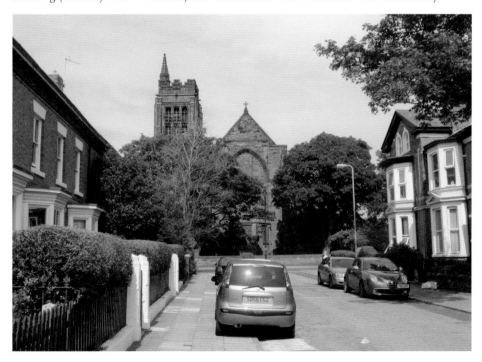

47

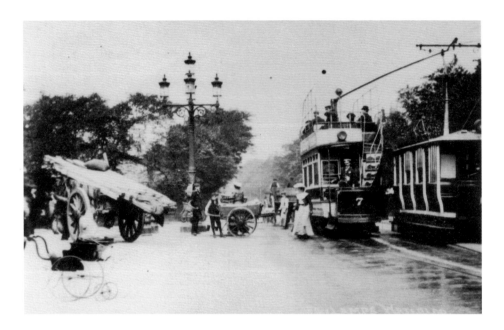

Five Lamps

Many different forms of transport jostle for space in a busy scene by the old ornate and decorative Five Lamps. Alongside the standard double-decker tramcar on the passing loop is one of the cramped, open-sided 'summer cars', withdrawn in 1914. Besides the two horse-drawn carts (the one on the left drinking from a trough) there is one drawn by hand, a pram and a pedlar man. There is a beautiful and moving sculpture in an unusual pose on the memorial recording the names of those who died in the world wars, but the elegant harmony of the old Five Lamps is in marked contrast to the discordant asymmetry of the new.

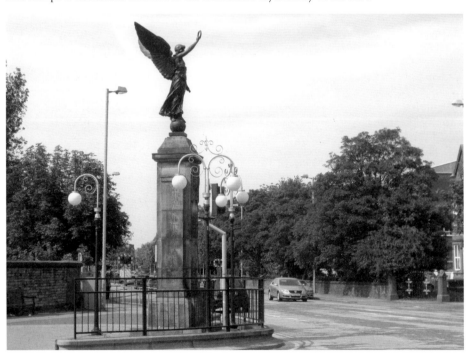

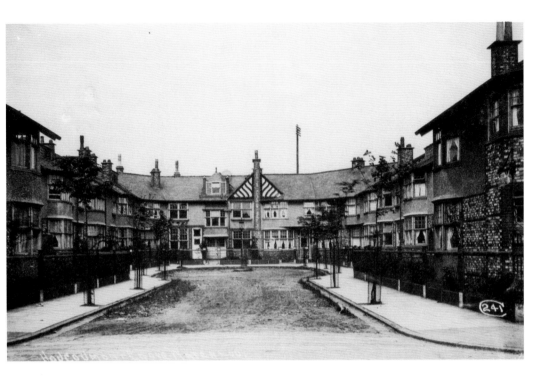

Hougoumont Grove

The Chateau d'Hougoumont played a pivotal role in the Battle of Waterloo. The reverse of the postcard (postmarked 9.15 p.m., 3 April 1909, address '7 The Grove, Waterloo') says, 'I will be in Town tomorrow evening Thursday. Will it be convenient for you to see me 8 o'clock Exchange station.' The confidence in a late posting and early delivery of a card is remarkable. Communications have changed and the trees have grown but the grove, in spite of the cars, conveys the same peaceful scene as when it was built.

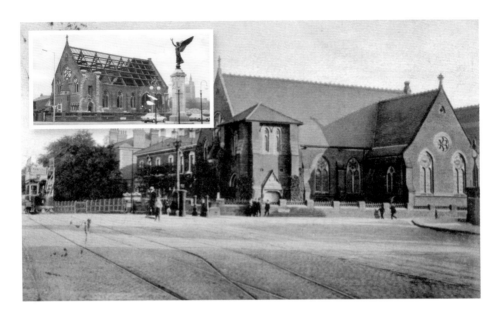

St Andrew's Presbyterian Church

In the days of the tram (1900–25), St Andrew's Presbyterian church is pictured by the Five Lamps in their former position and style. The church was first established in East Street in 1873 and the building shown was opened in 1876, with two transepts being added in 1887 and 1893. After demolition of the church in 1987 (*above, inset*), St Andrew's Court was erected on the site (*below right*) but the gateposts remain (*below, inset*). To the left on the opposite side in the distance is the Welsh Presbyterian church, shown being converted into residential accommodation.

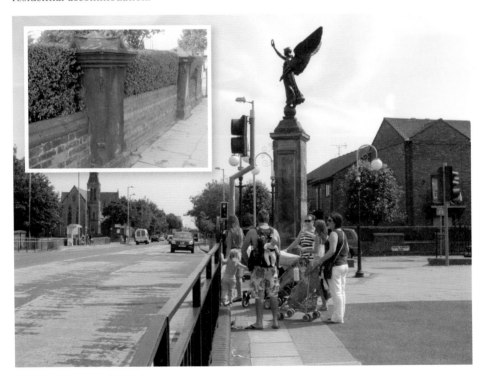

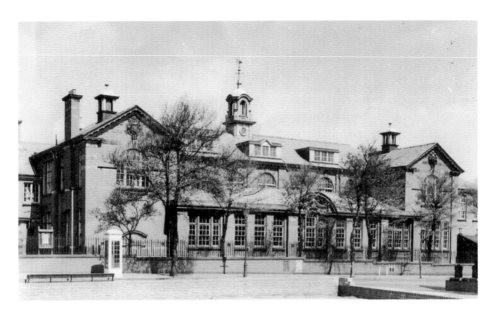

Waterloo Grammar School

Henry Leedam's School for Young Gentlemen for boarding and day pupils was established in Cambridge Road in the nineteenth century. After it closed, the present building was opened as Waterloo-with-Seaforth Secondary School on 1 October 1912. It became a boys' school when the Waterloo Park School for Girls opened in 1921, although the last girls did not leave until 1927. It was then known as Waterloo-with-Seaforth Grammar School and later Waterloo Grammar School (WGS) in the mid-1930s. Closing in 1972 when comprehensive education came into being in Crosby, it merged with Manor Girls School and Waterloo Secondary School, moving on to the girls' school site. The old school in Cambridge Road is now the South Sefton Adult Education Centre. Shown in the inset is the centre's foundation plaque.

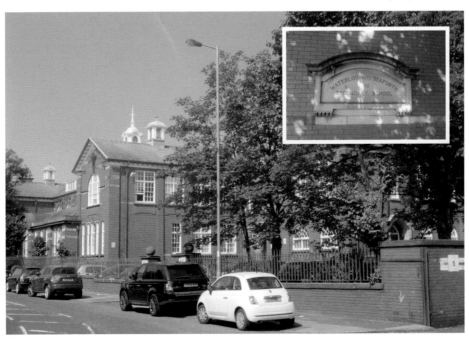

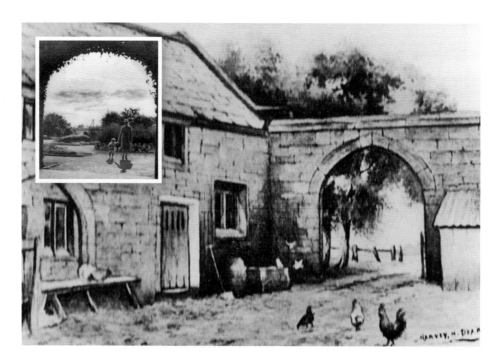

Potter's Barn

Two idyllic views encapsulate the dreams of William Potter, who conceived a plan to build a grand house on his land in 1841. However, his business interests failed in a trade crisis with China when only the entrance and stables had been completed. These were modelled on the farmhouse La Haye Sante, which played a key role in the Battle of Waterloo. Afterwards, they were affectionately dubbed Potter's Barn and the initials 'WP' over the entrance preserve his memory. The surrounding land was converted into a public park.

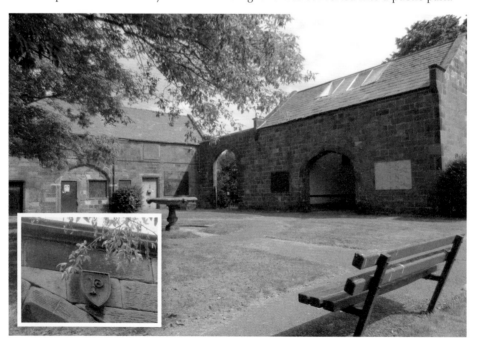

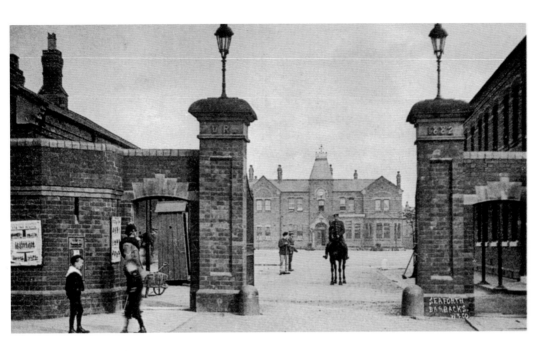

Seaforth Barracks

Built in 1882, as the gateway proclaims, the barracks, designed for cavalry, became an artillery depot, providing training for 200 recruits. The men serviced the Seaforth Battery sited at the present-day Gladstone Dock (opposite to a battery on Perch Rock at New Brighton), as pictured below firing the King's birthday salute. Besides the living accommodation, the premises boasted a huge drill shed, tennis ground and wireless station. During the war, American servicemen arriving in Liverpool were based there in spartan conditions before proceeding to fight on the Western Front. Terrace housing has replaced barracks in Claremont Road (*inset*).

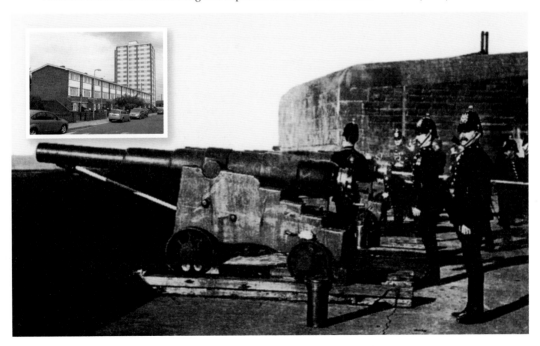

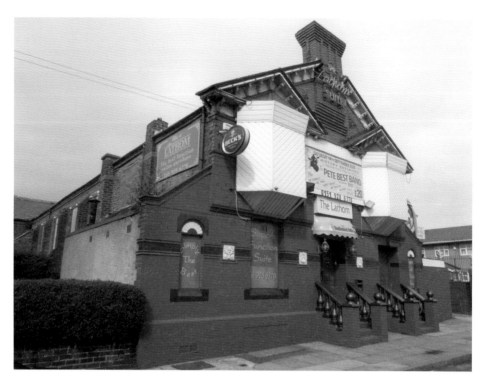

Lathom Hall

In 1960, Lathom Hall saw the first appearance of the 'Silverbeats' (should have been 'Silverbeatles', later The Beatles) on the same billing as Seaforth's own rock 'n' roll group, The Dominoes. The 'Silverbeat(le)s' turned up without a drummer, so local lad Cliff Roberts from the Dominoes stood in for him. 'BEEKAY' is the promotion name of Brian Kelly, who also used Alexandra Hall, as mentioned in the advert. Built as a social club in 1884, the hall was used as a cinema for twelve years and during the Second World War served as a NAAFI and the Royal Naval Association, commonly known as the Navy Club. Today, 'The Lathom' has been converted into a shrine to the Liverpool sound of the 1950s and '60s, with displays of memorabilia. It is run by Merseycats, a charity devoted to raising money for Alder Hey Children's Hospital and sick and deprived children in the Liverpool area, with performances of music of the time each Thursday by members of original Merseybeat bands.

BEEKAY presents

JIVE AT LATHOM HALL

Every SATURDAY

THIS WEEK — SILVER BEATS, DOMINOES, DELTONES.
7-30 — 11-30. Admission 4/-. Members 3/6

FRIDAY TO-NIGHT — Transferred to ALEXANDRA HALL
(I.1, I.3, I.30 to door). 7-30—11 p.m. Admission 3/-

EVERY MONDAY 7-30 — 11 p.m. Admission 2/6
THIS MONDAY — CLUBMEN

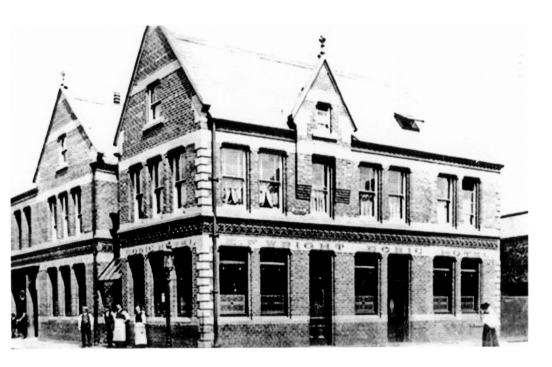

Doric Hotel

At one end of Rawson Road still stands the Doric Hotel. Here streets were named after the orders of classical architecture (Corinthian, Roman, Ionic, Doric, Tuscan), culminating in Grecian Street. Roman and Tuscan have appropriately disappeared, leaving the Greek orders and their titles intact. It is not as easy to enter or leave as in 1905 and the building has lost some minor embellishments, but otherwise has weathered the storm of change and is enhanced by the rowan trees in full berry opposite.

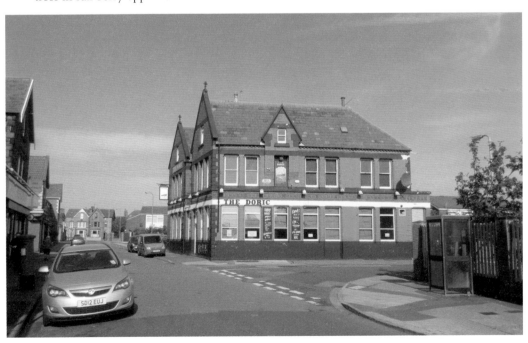

Rawson Road

At the other end of Rawson Road, schools were built on the corner of Elm Drive. The corner shop has gone together with most of the housing and the Northern Bowling Club on the right, which later transferred its grounds to Waterloo and then to Crosby. Princess Way has now brutally severed the artery; although a subway has been provided for pedestrians and cyclists, a car has to travel over a mile to reach the far side of Rawson Road. The dual carriageway, named after Princess Anne, brings container traffic to the Royal Seaforth Container Dock, which the Princess opened in 1973 when she endowed it with the title of Royal.

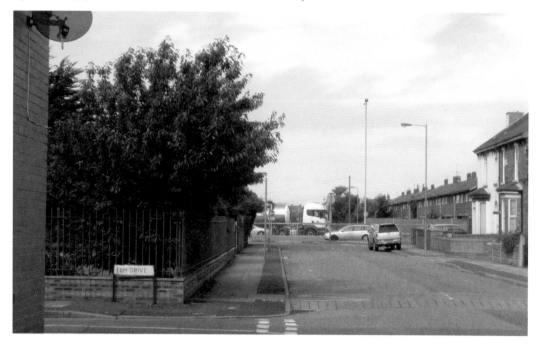

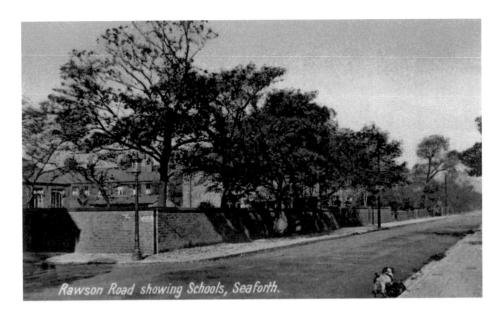

Rawson Road showing Schools, Seaforth.

Rawson Road Schools

A dog is caught scavenging in the neat piles of rubbish and looking at the schools. The road is named after William Rawson, the first minister of St Thomas's church. He lived in a parsonage built for him by John Gladstone on a site that later became Seaforth police station. In his early ministry, William also augmented his income by preparing boys for Eton and other public schools (including William Gladstone and other eminent politicians and clergy). A remnant of the original walls around the Gladstone estate has survived the onset of the container port. Just out of view at the end of the flyover is the International Marine Hotel (*inset*), one of three magnificent Victorian pubs in Seaforth that are now closed.

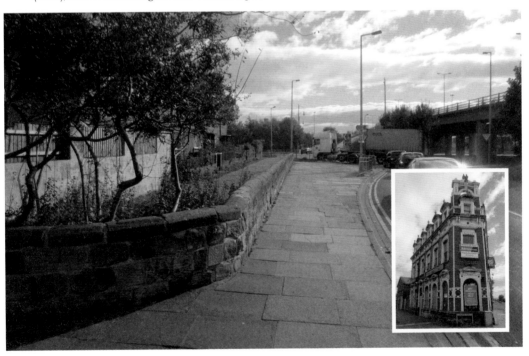

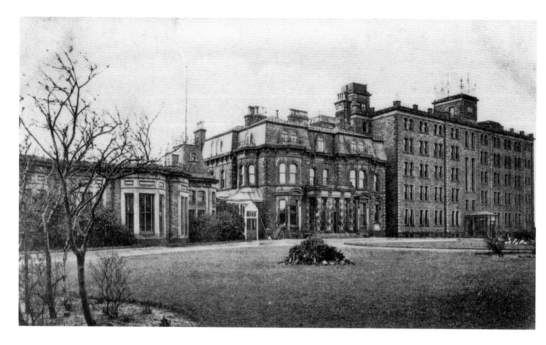

Seafield House

Rarely can a building have experienced such varied uses and vicissitudes. William James Fernie designed Seafield House as a luxurious hydropathic hotel for 200 guests, opened to great acclaim in 1882. Two years later, a downturn in the market precipitated its closure. The Sisters of the Sacred Heart of Mary converted it into a convent school, as pictured here. The early years of the twentieth century brought further change; it was bought by the Mersey Docks and Harbour Board, envisaging an extension to the Gladstone Dock, and with the money gained the Sisters moved to new premises in Crosby, keeping the old name. However, it lost its top two storeys in the process of being converted into a mental asylum, owing to a fire allegedly started by suffragettes. It was demolished in 1970 to make way for the Royal Seaforth Dock, pictured below with nature reserve in the foreground. In between, it had been leased for use as a Royal Naval Hospital and offices for the Inland Revenue!

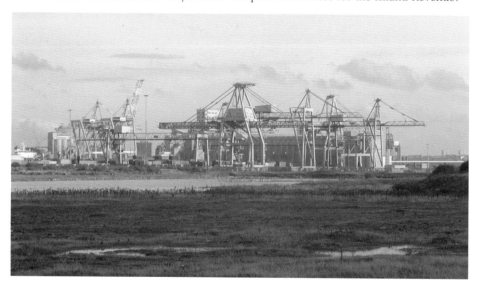

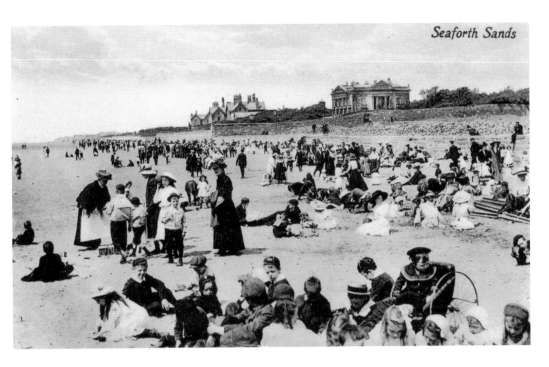

Seaforth Hall

Overlooking the beach with its unbelievable beachwear and hats is the home of James Muspratt, founder of the Lancashire alkali industry. Seaforth Hall (not to be confused with Seaforth House, home of the Gladstone family) was built with a vast, colonnaded entrance and windows affording magnificent views over the river all in expansive classical style and surmounted by pediments. The hall was demolished in the 1920s to make way for an extension to the Gladstone Dock and has been replaced in architectural distinction by a grain terminal.

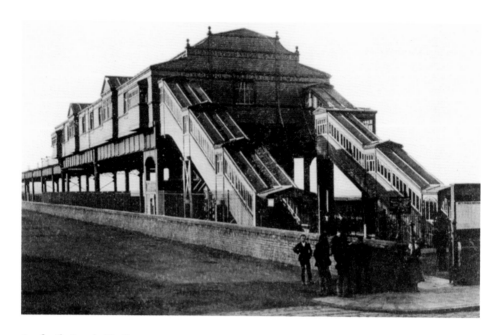

Seaforth Sands Station

The Overhead Railway was opened from Liverpool and the Herculaneum Dock to Seaforth Sands station in 1894. Seen here in its original state, it had not yet acquired its escalator – only the second in the country – installed in 1901. Shortly before the line was extended to Seaforth and Litherland station in 1905, the escalator was removed, largely because of impending claims from women whose skirts had become entangled in the exposed machinery. The wall replacing the abutment to the embankment on the east side of the bridge has decorative brickwork portraying a three-coach Overhead Railway train and a goods train that ran on the tracks beneath it.

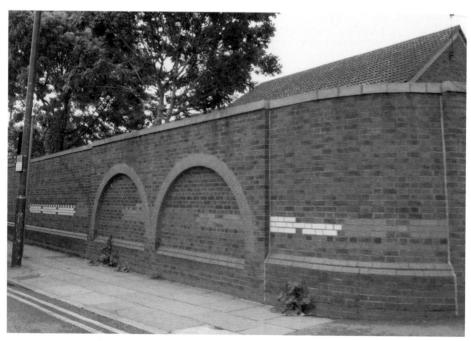

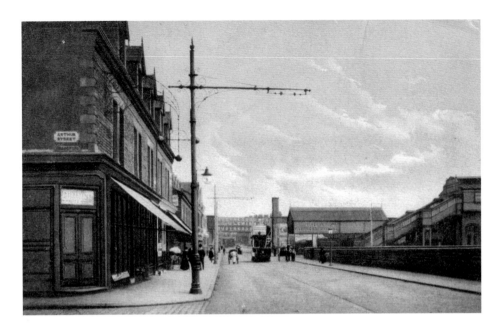

Overhead Railway

The supports of the tram posts, lamp posts and the three balls of the pawnbroker sign form a beautiful and intricate patterning in the early nineteenth-century view along Crosby Road South. The bridge carrying the Overhead Railway extension to Seaforth and Litherland station seems to advertise Lewis's. The tram is on its way to Crosby on a service run by the Railway from 1900 to 1925. Arthur Street and the bridge that used to create a bottleneck for traffic trying to stream in to Liverpool are no more, but the Caradoc Hotel still stands on the corner of Seaforth Road. Pictured inset is a model of an Overhead Railway station and Liverpool tram in the Bowersdale Centre.

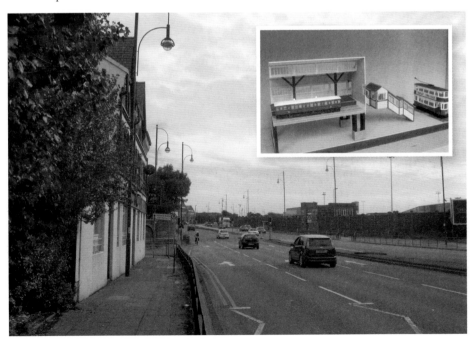

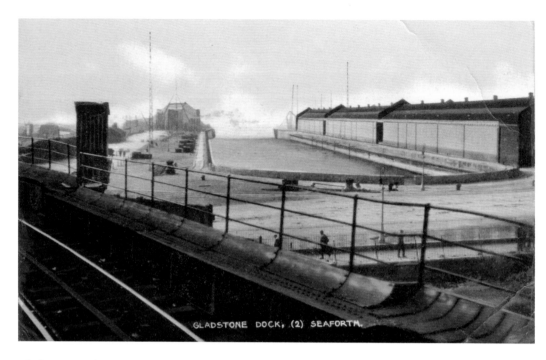

GLADSTONE DOCK, (2) SEAFORTH.

Gladstone Dock

Soon after leaving Seaforth Sands station on the Overhead Railway into Liverpool, the track curved round to start the most exciting part of the journey along the dock system. The Gladstone dock was the first one, apparently still under construction in the view taken from a train at this point (the electric conductor rail in the centre of the track was changed to the outside in 1905 to allow through running from Southport to the Dingle, and construction of the dock began soon after). This is the position of the Rimrose Bridge, where the old brook flowed into the Mersey and formed the boundary between Seaforth and Bootle at the far end of the wind turbines.

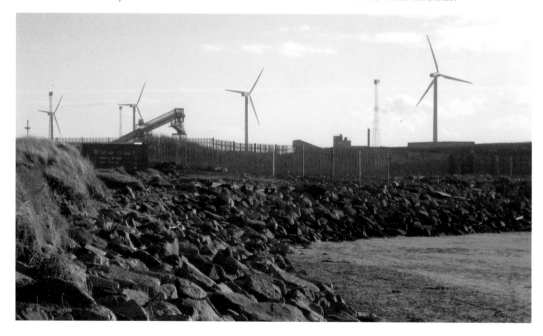

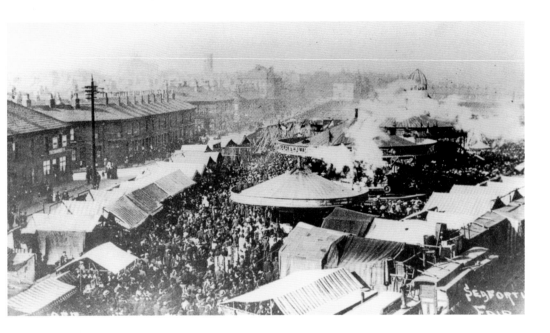

Seaforth Fair

On the other side of Seaforth Road, and doubtless packed with visitors from the fair, the Castle Hotel is barely visible through smoke from steam engines powering the merry-go-rounds. Beyond rises a huge helter-skelter. On the skyline is the tower of St Thomas's church and, to the left of it, the apex of Star of the Sea church. The large carousel bearing the name of the proprietor, J. Wallis, boasts that it is 'patronised by the nobility & the elite of the country'. This fair of 1906 was held on the triangle of ground between Seaforth Road and the Overhead Railway extension to Seaforth and Litherland station, formerly a timber yard, and the photograph was taken from the railway embankment. In the 1960s, the Castle Hotel was still well looked after. Today (*inset*) it is sprouting vegetation and boarded up.

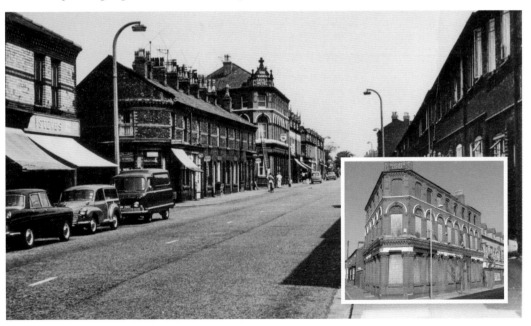

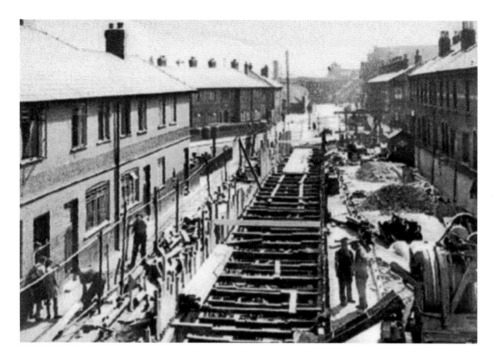

Seaforth Road

It is 1947 and a new sewer is being laid down Seaforth Road. Workmen and residents stand and talk. On the left, housing has been built on the land used for the fair, but on the right some of the buildings have remained to this day and new development has encouraged the growth of trees. In the distance, Seaforth Sands station has been replaced by a grain terminal, and over all loom the cranes of the container dock.

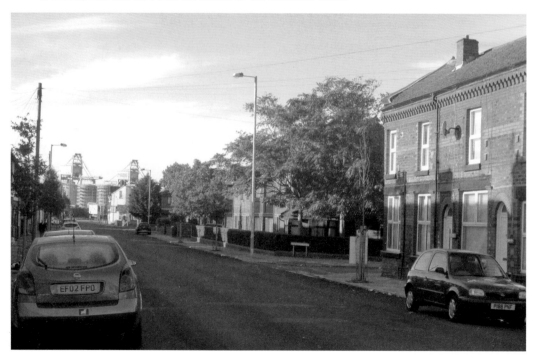

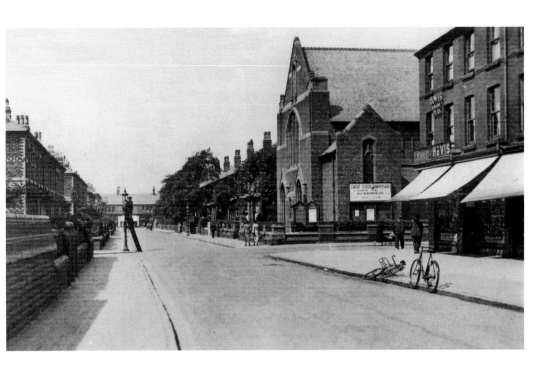

Elm Road

Why is everyone walking away from the camera? And if the lamplighter cleaning the lamp is staged (his ladder is inappropriately standing on the road), is the overturned bicycle as well? The Congregational church, bombed during the war, has disappeared together with some of the trees, though others have grown. The property opposite has gone, but otherwise the terraces survive, complete with front wall and gateposts immediately on the left. In the distance, shop-fronts on Rawson Road indicate that trading has continued from that day to this.

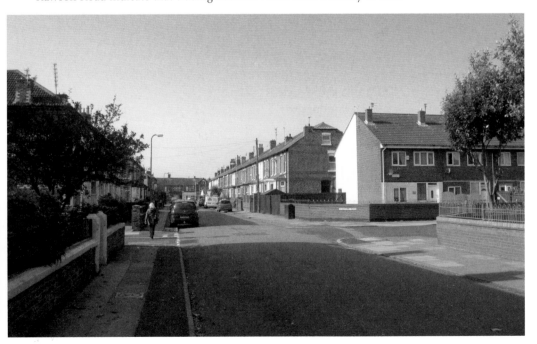

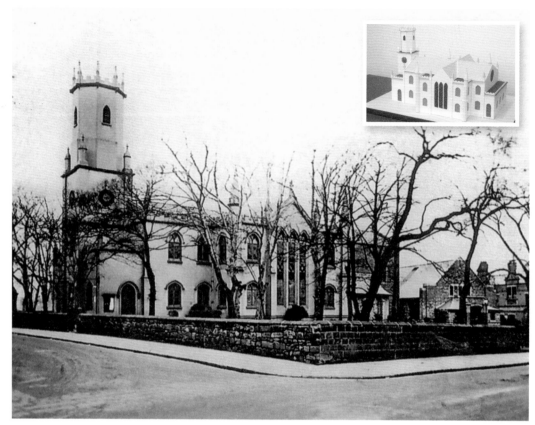

St Thomas's Church

John Gladstone, William's father, endowed and built this church in fine white, stucco-faced Georgian style with a tower embellished by pinnacles and four gilded clock faces (*above, inset:* model in Bowersdale Centre). William Rawson preached the first sermon on Christmas Day 1815 and was minister for fifty-seven years until his death. St Thomas's was closed in 1976 and demolished, but services continued in the church hall until that too was demolished and recently replaced by housing. Opposite is the church of Our Lady Star of the Sea (opened on the eve of the twentieth century) and here in 2012 was unveiled a bust of William Gladstone (*lower right in photograph*). On the other side of the road, St Thomas's gateposts still stand (*left, inset*).

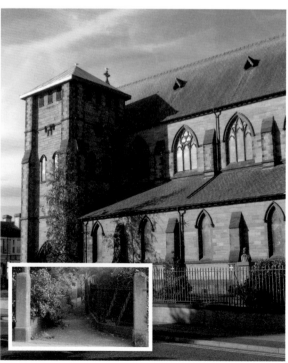

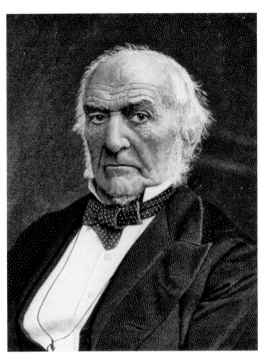

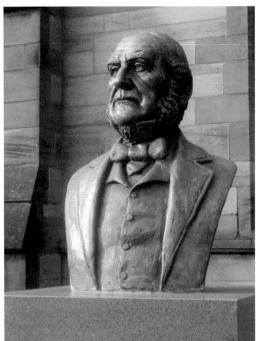

William Ewart Gladstone
An old photograph contrasts with a recent bust portrait. This, with an accompanying inscription (*right*), was funded with money raised by Brenda Murray BEM. Gladstone, born in 1809 in Rodney Street, Liverpool, grew up in Seaforth.

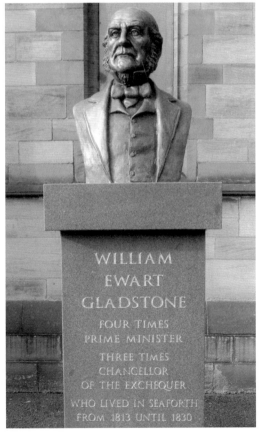

WILLIAM
EWART
GLADSTONE
FOUR TIMES
PRIME MINISTER
THREE TIMES
CHANCELLOR
OF THE EXCHEQUER
WHO LIVED IN SEAFORTH
FROM 1813 UNTIL 1830

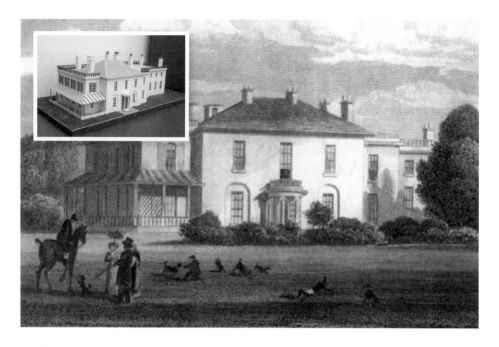

Seaforth House

John Gladstone named his family home Seaforth House after Lord Seaforth, the head of his wife's Scottish clan, thus giving its name to the surrounding area. The inset shows a model in the Bowersdale Centre. Following demolition of the house in 1881, the site was developed for housing. Now Gordon Road on the right of the recent photograph has lost one side to Princess Way, which runs parallel to it, taking traffic to and from the Royal Seaforth Container Port. Ironically, this new thoroughfare has obliterated all traces of the house that gave Seaforth its name.

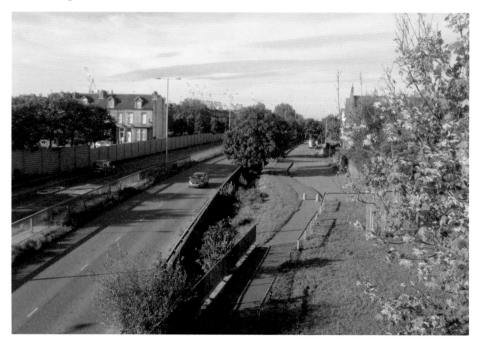

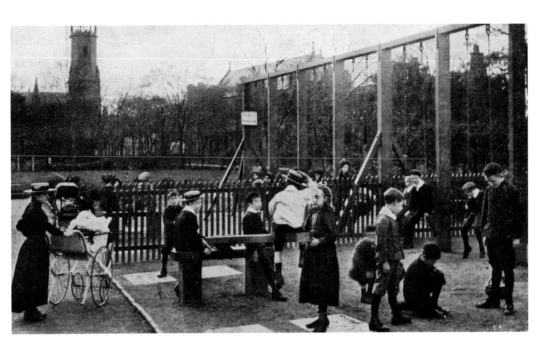

Bowersdale Park

A carefully staged photograph of 1905 packs an almost impossible variety of activities into a small playground. The numbers using it may be misleading in contrast to the present-day view taken on a Sunday morning. There have been great changes: St Thomas's church (*above, left*) has disappeared, along with an ornamental lake. The 1930s Bowersdale Centre, repository of the original Gladstone bust, is in the foreground with Our Lady Star of the Sea behind. The park is a remnant of the estate of Bowersdale, a house built by businessman Anthony Bower in the nineteenth century.

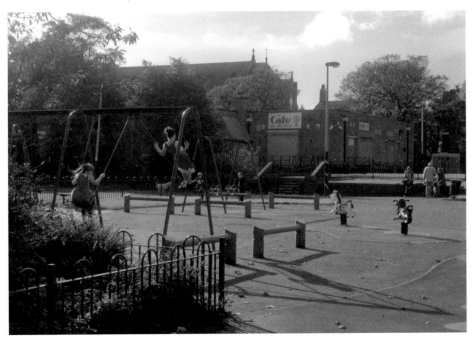

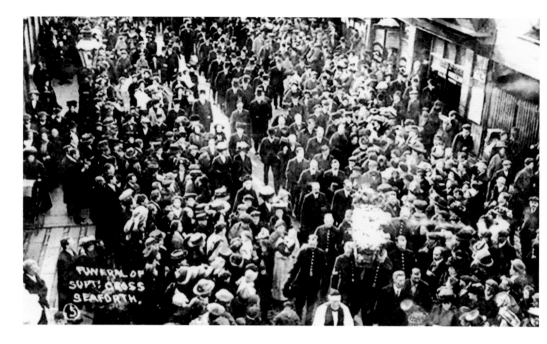

Superintendent John Cross

'This memorial was erected in the year 1912 by public subscription to perpetuate the memory of John Cross for 17 years superintendent of police of this division. By his noble life & kindly action especially to the poor for whom he founded the soup kitchen he was the true friend of all in need or distress.' This inscription on the fountain at the south-east entrance to Bowersdale Park explains the support he received at his funeral in 1911. The police divisional headquarters were on the other side of Seaforth Road 100 yards away. Inset is his portrait on the memorial (a listed building).

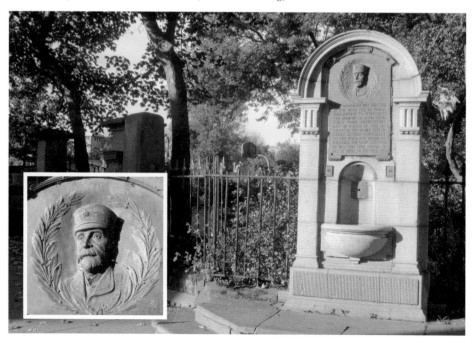

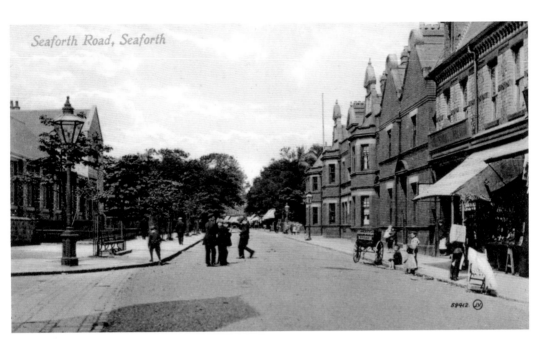

Seaforth Road, Seaforth

Seaforth Road Police Station

The road looks like a pedestrian precinct, safe enough to sit on the kerbs! However, pedestrians seem to be giving the imposing building of 1895 on the right a wide berth – the Lancashire County Police Station Division Headquarters! The division, under Superintendent Cross, and stretching from Croxteth to Hightown, consisted of an inspector, nine sergeants and forty-six constables, with stables at the Lime Grove entrance. Opposite is St Thomas's church hall and beyond it the Palladium has yet to be built (*below*). After being superseded by a new building in Waterloo, the police station survived as commercial premises until demolition and replacement by an apartment block.

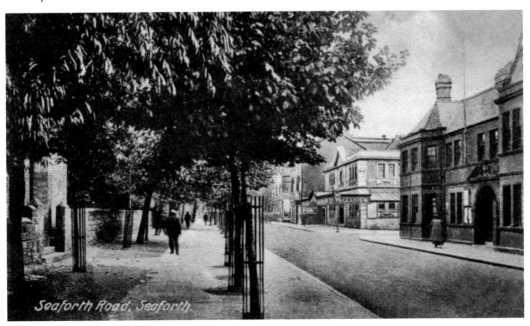

Seaforth Road, Seaforth

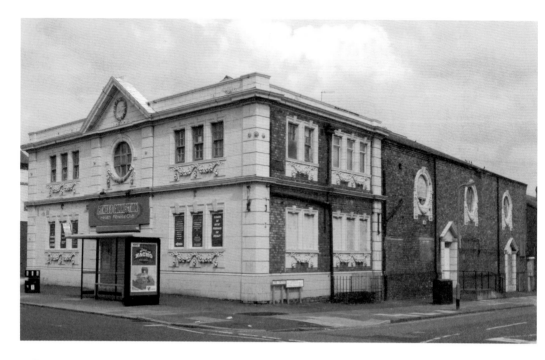

Palladium, Seaforth Road

Unveiled on Christmas Day 1913, the 905-seat Palladium started brightly but suffered from the competition of nearby cinemas and closed in June 1959. The building has a fine classical façade and matching decoration down the sides with pediments, pilasters and swags of fruit and flowers in moulded brick, now home to the Fitness Connection gym. Just down the road opposite the fine curve of terrace shops was a competitor, the Stella. The inset shows a puzzling plaque on the corner of the terrace.

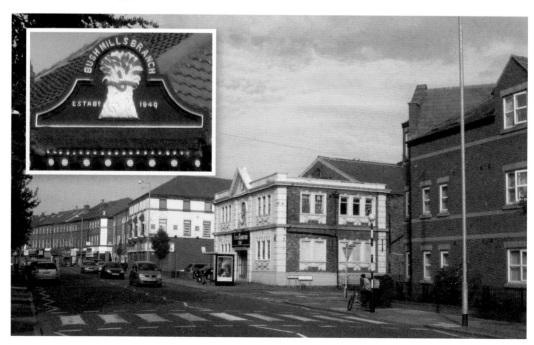

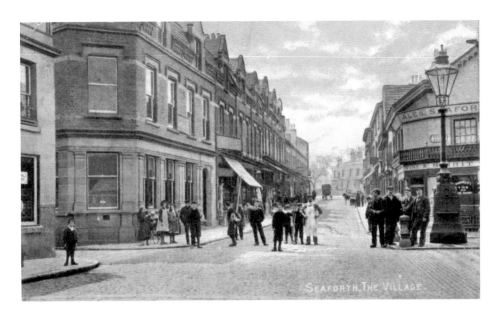

Seaforth Village

You would find it difficult now to gather such a crowd in the morning (as the shadows and the present-day photograph show). The handsome bank building on the left with its classical pilasters flanking windows and doorway survives – just (*see inset below*)! In its heyday this was the focal point of the village, centred on the fountain. On the right is the old Seaforth Arms, victim of a substantial road widening. Since then, a new Seaforth Arms up the road on the right has been built and beyond it in a recent photograph can be seen the Stella precinct shopping centre on the site of the Stella Cinema, which opened in 1920. Billed as a 'super cinema' with white glazed stone, luxurious seating for 1,200 and a huge star on the screen arch, it closed in 1958 and, after a brief spell as roller skating rink, was demolished in 1964.

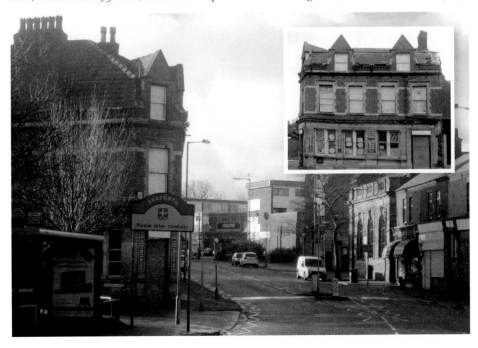

73

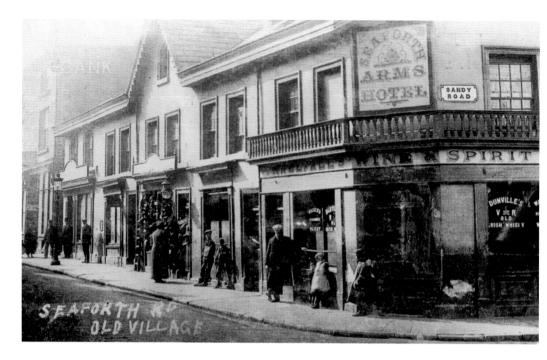

Seaforth Arms Hotel

Formerly the Royal Oak, dating from at least the late 1840s, the original Seaforth Arms Hotel stands on the corner of Seaforth Road and Sandy Road at the hub of the village. All ages are gathered round and social life thrives outside as well as within. In the last decade of the nineteenth century, it was rebuilt just up the street on a much more lavish and palatial scale with conveniences to match. However, changing social habits and the decline of attractions in the village took their toll. Closed now for three years, it awaits its fate.

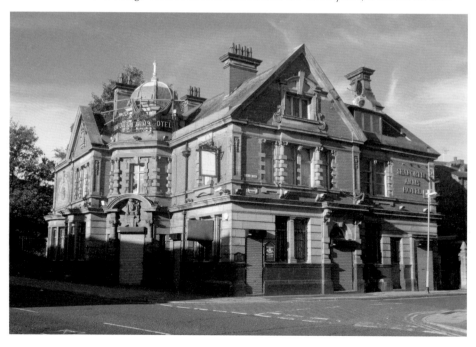

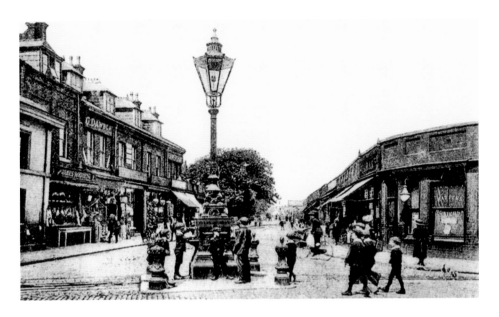

Sandy Road

A vibrant, bustling community fills Sandy Road. At its heart is a fountain with twin basins and iron cups on chains surmounted by a magnificent gas lamp, the gathering point for New Year celebrations. It is surrounded by bollards to protect it from ever-increasing traffic, which forced its removal in 1929. Now the road, without even a nameplate at this end, has been severed by the dual carriageway bearing containers to and from the dock. It has lost purpose and life. Gone are any vestiges of its forerunner, Sandy Lane, leading to a whippet track and the 'Whabbs' (the lower end of Rimrose Valley). But the corner shop chemist that replaced the Seaforth Arms, Ashworth Whittaker, still displays the circular alcove that held a clock.

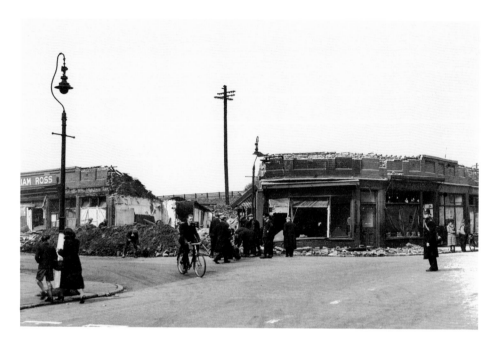

Sandy Road War Damage

Workmen are beginning to clear away the rubble after the demolition of a shop (J. Olswang) in 1941. The debris still left on the pavement indicates it is the morning after the air raid. The area was targeted and suffered badly, Litherland because of its industry and Seaforth because of its proximity to the docks. Life goes on as if nothing particularly unusual has happened. Only the policeman and an inspector of the clearance gang show official interest. Now, a passing container truck is evidence of further demolition to make way for the new road to the docks!

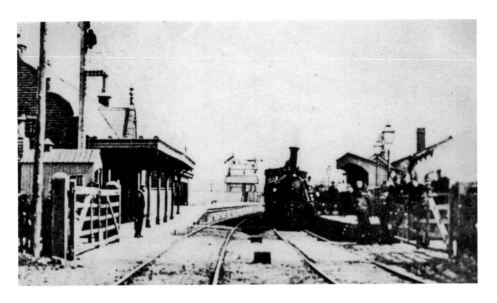

Seaforth and Litherland Station

It is 1876 and a Southport-bound train has stopped at Seaforth station, which had been opened with the line in 1850. Ahead is a split signal, indicating that a Liverpool-bound train is due to arrive but not diverted on to a spur on the right, leading to the North Mersey branch line from Fazakerley, which ran to the docks. The railway originally ran on ground level at this point as far as a steep ascent to the canal crossing at Bootle, so the track was raised between 1885 and 1887 to eliminate this and the awkward level crossings, as shown above. When the spur line closed in 1886, the extension of the Liverpool Overhead Railway from Seaforth Sands in 1905 followed a similar course and the station was renamed Seaforth and Litherland. Now, looking in the same direction from the other end of the platform as a train leaves the station for Liverpool and Hunts Cross, you can see little of the tree-covered earthworks for this on the right. The bridge over the railway ahead carried the Seaforth Connecting line. This ran from the North Mersey branch (from the left) to the Liverpool Southport line at Marsh Lane junction ahead, beyond which looms the Triad office block in the centre of Bootle.

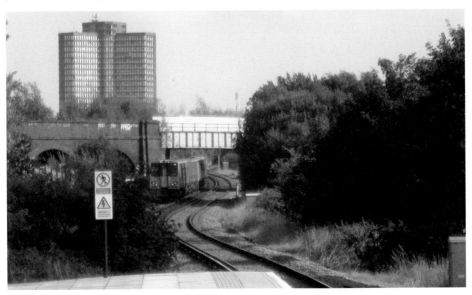

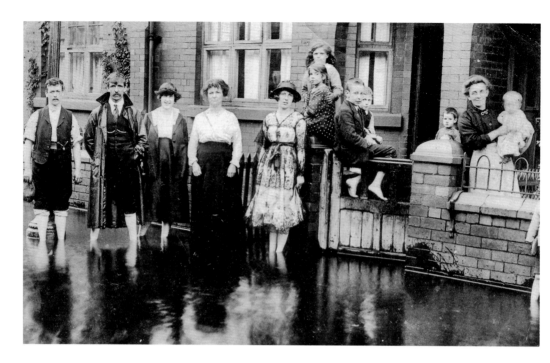

Rimrose Brook/Valley

Residents of Seaforth can be afflicted by floods caused by the natural drainage from the Rimrose Valley. There is also a picture of burst manhole covers in Bridge Road. Historically, the valley was a low-lying area, which, along with the brook, separated the old townships of Crosby and Litherland. The site was particularly prone to flooding so remained largely unsettled. Now, the brook has been culverted or can barely be seen as it now meanders here through the reeds. The phragmites reed has caused it to be declared a site of Special Local Biological Interest (SLBI).

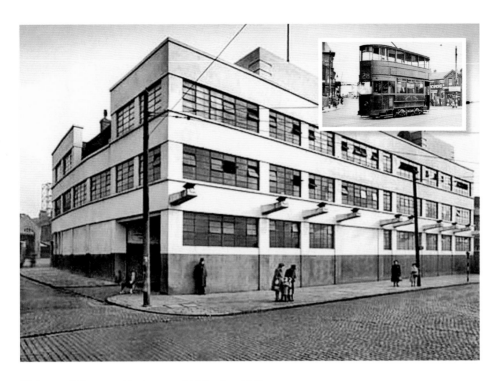

Richmond Sausage Factory and Litherland Library

Around 1889, Louis Moore opened a butcher's shop at No. 63 Linacre Road and expanded to build a factory on the site in 1917 (*inset*). At that time there were Oxford beef and Cambridge pork sausages. His family being Methodists, he adopted the name of their college in London for his brand. In 1930, a larger factory was built, employing 230 people with 120 vans delivering all over Britain. The Moores sold out to Walls in the 1950s, but the factory was closed in 1970 and the eye-catching sign, with a jolly-looking pig carrying a sausage skewered on a fork over his shoulder, was removed. Opposite was the library, recently closed. The inset shows the fine modernist main entrance.

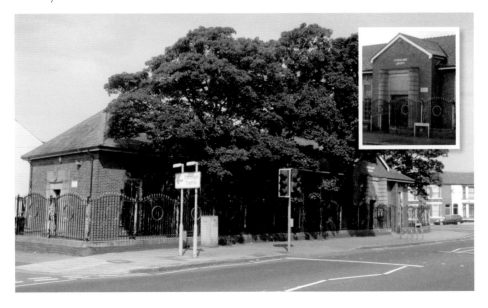

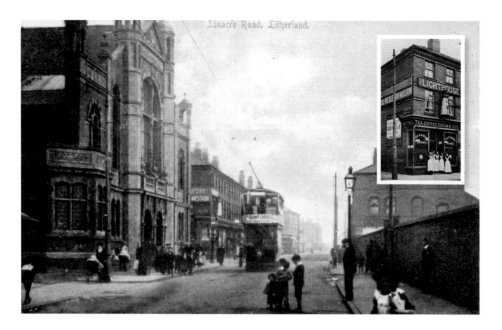

Linacre Mission

It is 1906 and people are gathered round the Linacre Methodist Mission in their best Sunday dress. Beyond can be glimpsed the Lighthouse Café, run by the mission and advertising cocoa (*above, inset*). The tram on its way to Bootle advertises Crawford's Cream Crackers ('crisp and creamy'). To the right, behind the brick wall, is the Diamond Match Factory. Originating in 1898 in a two-up two-down house, the first Linacre Wesleyan Mission was built in 1900 to house a congregation of 500. Their work prospered so much that in 1905 a new one was built in front of the existing one to accommodate 1,200. The inset below shows a detail of the beautiful architecture.

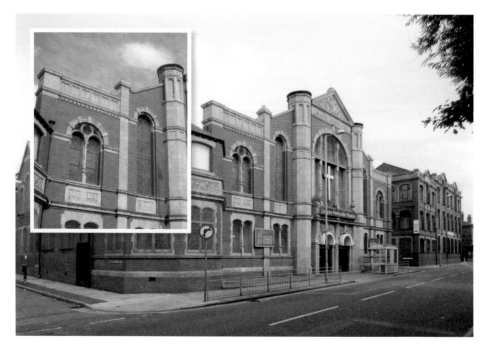

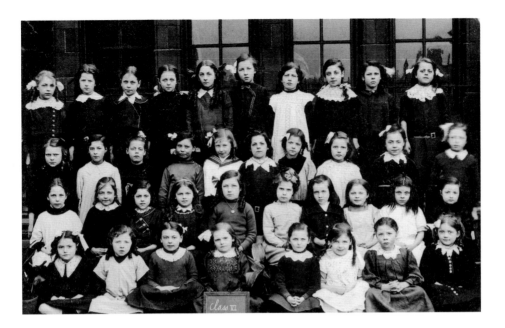

Linacre Mission Sunday School

The expanding work with young people, such as those pictured in a Linacre school in 1914, made it essential for new Sunday school premises to be built, which were opened in 1914 with a fully equipped gym and special rooms for the uniformed organisations and various groups. In the 1920s, Linacre Mission had a Sunday school of 3,000 children, which met at 3 p.m. The Children's Service and the Evening Service both started at 6.30 p.m. and were filled to capacity.

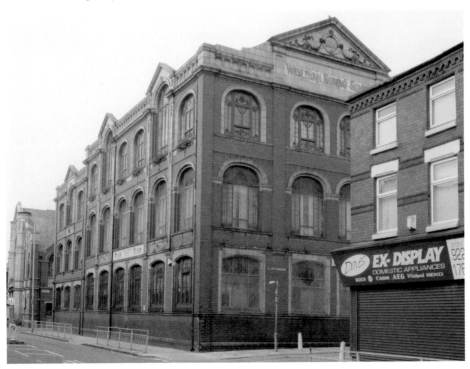

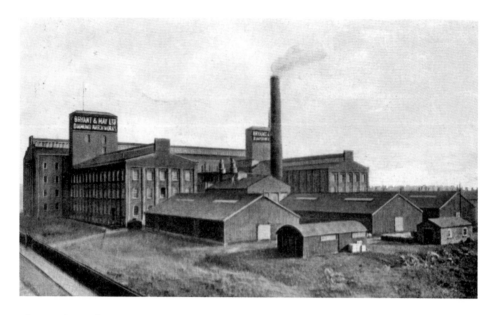

Diamond Match Factory

The site is now occupied by the Hornby flats opposite the Linacre Mission. In the centre of the photograph is a representation of a flaming match with the inscription 'The Matchworks factory that stood on this site was opened by the American Diamond Match company and at one time had a continuous match making machine that could produce 600,000 matches per hour. Bryant and May the UK matchmaker bought the goodwill of the factory in 1905. The Matchworks was one of the main employers in the area for over 40 years until it was destroyed in the May blitz of 1941.' The inset below shows this in more detail.

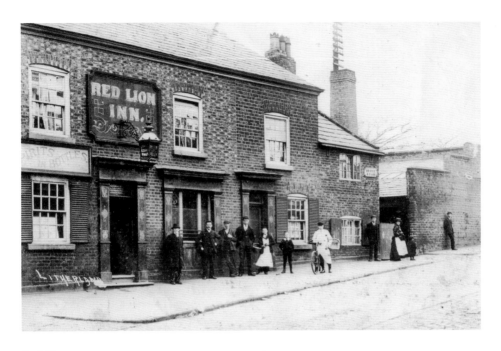

Red Lion

An all-male group face the camera in front of the old Red Lion while a mother stands discreetly to one side and a little boy averts his face. The unpretentious and homely building is in marked contrast to the extravagance, but inclusivity, of its successor. Well maintained, the pub is receiving its morning wash from the window cleaner on his rounds before the outside tables fill up at lunchtime on a hot summer's day while the sports fans watch inside, courtesy of Sky.

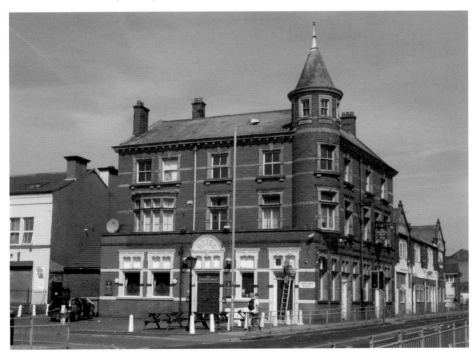

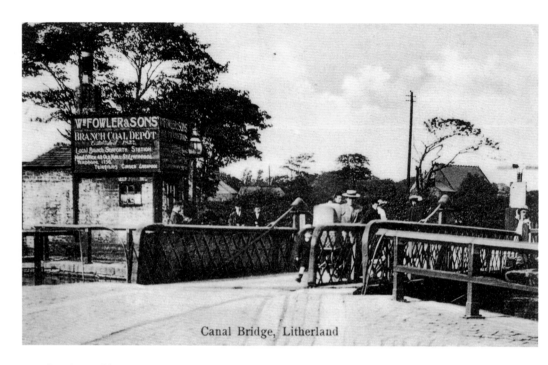

Canal Bridge, Litherland

Canal Swing Bridges

This section of the Leeds & Liverpool Canal was dug in the 1770s and the canal bridge has been rebuilt several times over the years, starting with a wooden one. In the earlier of the two photographs, taken around 1900, a strut supports the structure, providing an integral walkway. It was superseded by another similar bridge, as shown, but with the increase in traffic this was eventually replaced in 1933 by a lift bridge linked to warning lights and barriers.

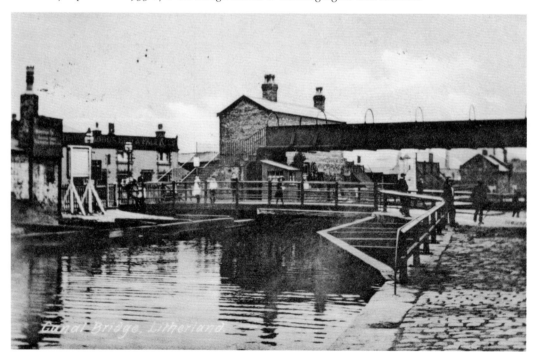

Canal Bridge, Litherland

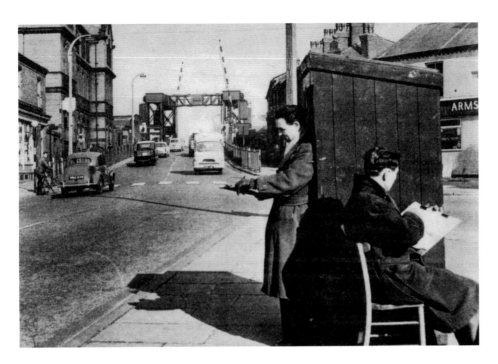

Canal Lift Bridge

In 1963, a traffic census was carried out and the bridge was eventually replaced by Princess Way, which serves the road traffic to the Royal Seaforth Container Dock, opened in 1972. The footbridge survives, closed to passengers, but is still useful for carrying telephone cables across the canal. The view is taken from under the shadow of the new bridge, and the connections for the old swing bridge can still be seen in the banks of the canal to the left.

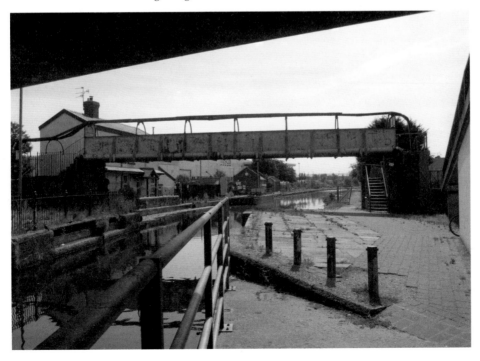

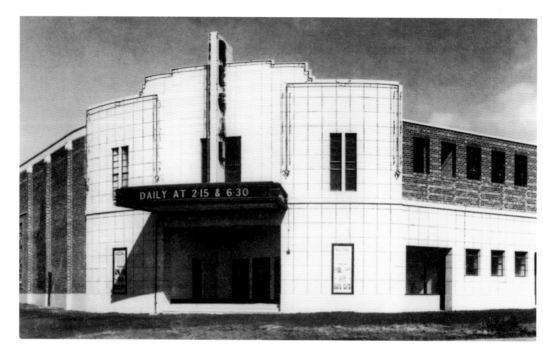

Regal Cinema, Church Road

As with so many cinemas, the Regal has seen a short working life, followed by conversion for other uses, demolition and replacement. Opened in June 1939 just before the start of the Second World War, it was forced to close in 1963, and then converted into a two-floor ten-pin bowling alley. When the popularity of that too declined, it became Allinson's Theatre Club, when it hosted celebrities of the day, and later Secrets Club until the end came in 2003. Architecturally, its successor echoes features of the original.

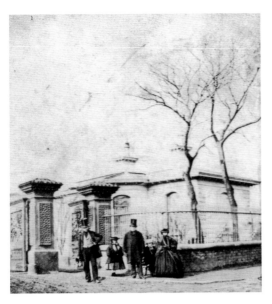 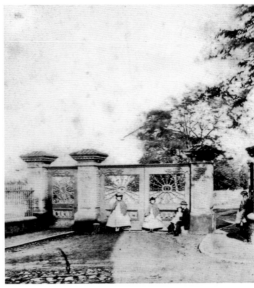

Litherland Park

Around 1845, a group of businessmen speculated in a plan to develop 'Litherland Park', drawing lots to see which building site they would win. By 1859, houses had appeared on the Ordnance Survey map. An 1862 view shows, in top hats, Mr Baines, the local constable, on the left and on the right Mr Baker, editor of the *Liverpool Mercury*. The imposing lodge marking the entrance to the 'park' can be seen to the right. Another view shows the beautifully ornate gates, which unfortunately have no place for modern traffic, although the gateposts survive, one embedded in the wall to the left.

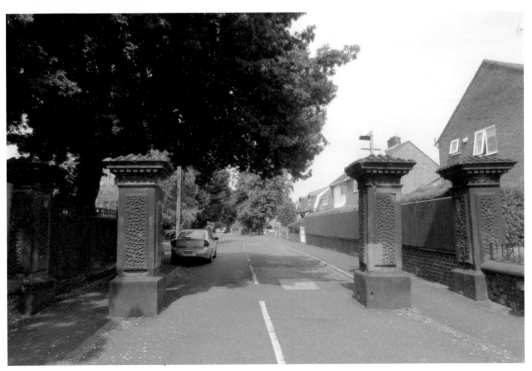

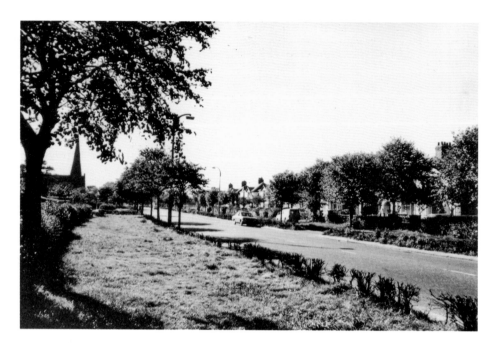

Church Road

A vast expanse of verge was a gift to urban planners wishing to drive an arterial road through the neighbourhood. The residents were rewarded with double glazing, which enabled them to see more clearly the continual stream of commuter and goods traffic passing to and from the Royal Seaforth Container Dock, albeit in comparative quiet. The road had the unfortunate effect of dividing Litherland, as it did Seaforth, in two. St Philip's church, visible in the distance to the left, lost a strip of its garden. The church was founded in 1861 by a group of businessmen from Litherland Park, who met in the Litherland Hotel. There were links between them and the Mock Corporation of Sefton.

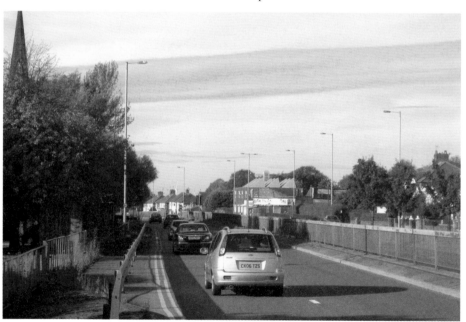

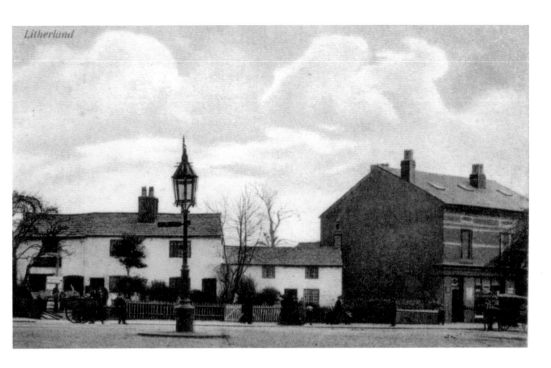

Litherland Village

The premises of an old dispensing chemist shows off its classical façade and beautifully patterned brickwork before acquiring an eye-catching advertisement. Enterprising shop owners of the era often used blank, side-facing walls for such advertisements, and many have lasted well beyond their time, but unfortunately in this example historical interest has been half obliterated by its present owners. The ornate lamp post has disappeared together with the small village green that used to be to the left of it.

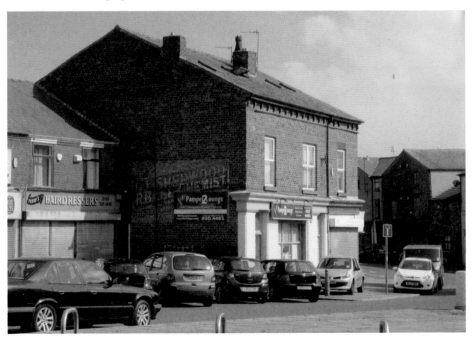

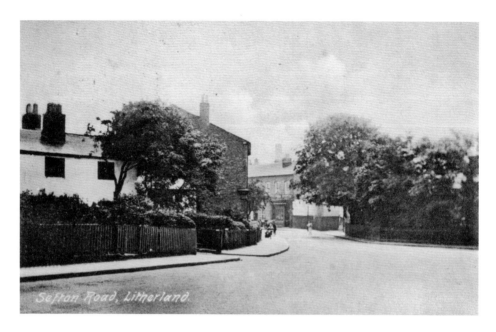

Sefton Road, Litherland.

Sefton Street

We are looking at the still unadorned end wall of the dispensing chemist, but further round the corner into Sefton Street. On the opposite side, on the right of the photograph, are some more shops that still survive. These can be seen to the left of the present-day scene looking the other way. The street, once a thoroughfare, has become a backwater, cut off by the new road. The buildings to the immediate left back on to the canal, as the inset shows.

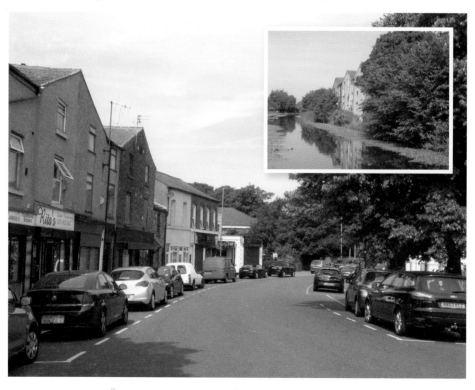

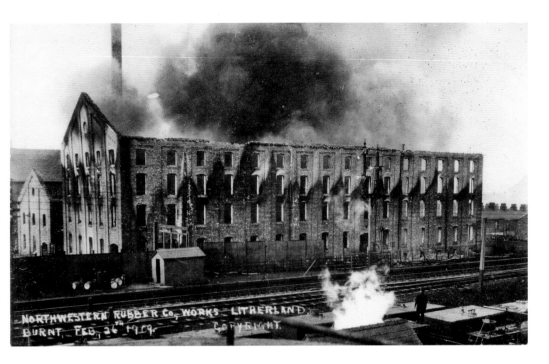

Rubber Factory

There was a disastrous fire at the North Western Rubber Company, one of Litherland's largest industrial plants, in 1909. The works was important enough to have a siding of its own from the line to the Gladstone Dock. A few years later there was an explosion (recorded in *The Engineer*) of a steam-jacked boiler and a fireman was killed there during the Second World War on 24 January 1944. A new Tesco now occupies the site.

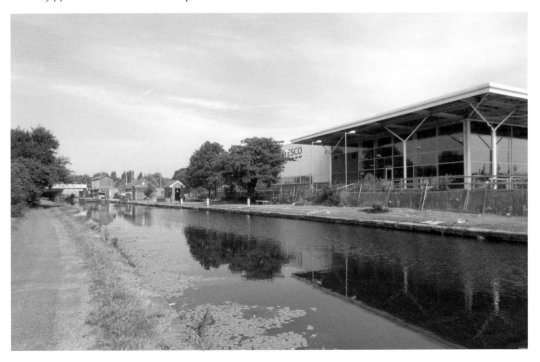

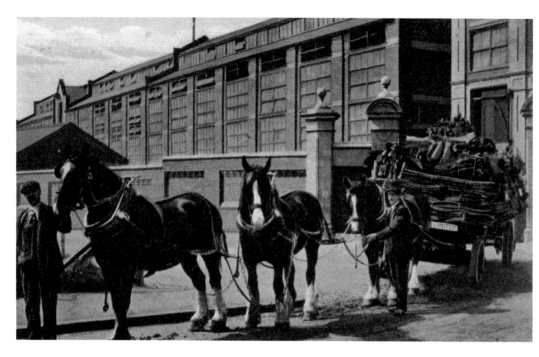

Hawthorne Tannery: Start

Three horses controlled by two men draw a load out of the Hawthorne Tannery on Hawthorne Road. In the boom days of leather between the wars there were as many as six tanneries in Litherland. This one opened for business in 1896 and was also known as the Walker Tannery, named after the family who built the premises (and also the Linacre Mission, using the same type of brick, hence also referred to as Walker's mission).

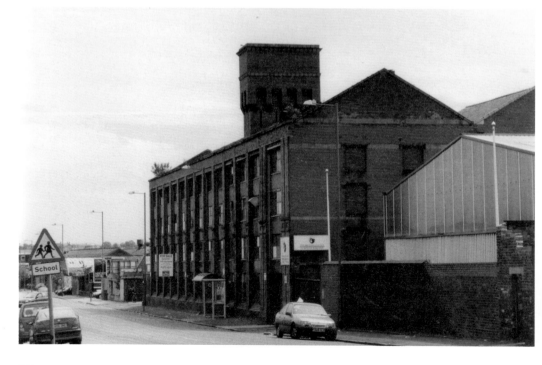

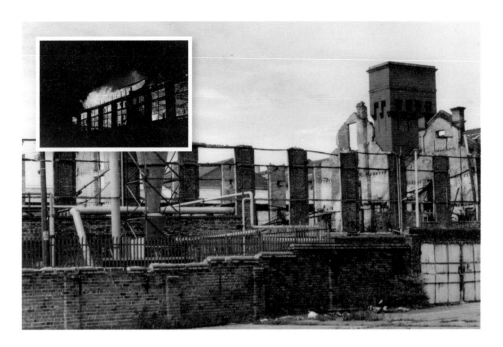

Hawthorne Tannery: Finish

The tannery continued producing first soles and then uppers until the arrival of synthetic materials in the 1950s. The works manager, later director, Mr Halliwell, invented K's Aqua Skips in the 1960s, which kept the factory going. However, production, now primarily catering for the luxury market, ceased. The building was for sale and already bearing the signs of an ancient ruin (*see opposite page, below*) when it was completely devastated by fire under mysterious circumstances. The site is now occupied by housing with restoration of an attractive canal bank.

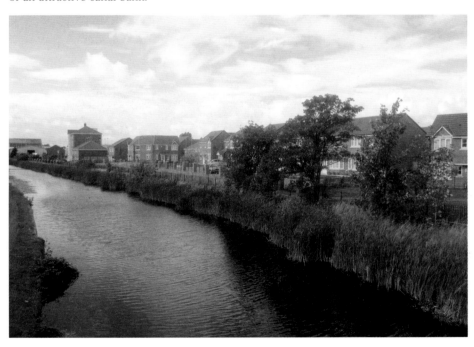

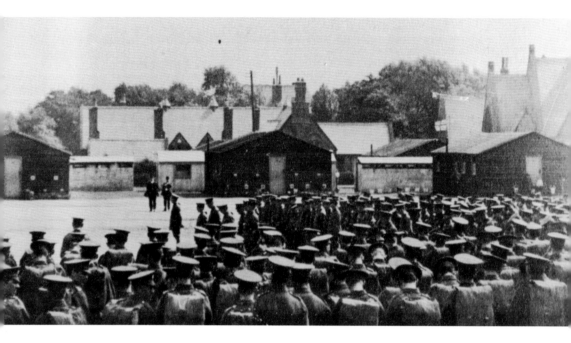

Army Camp and English Martyrs

First World War soldiers (possibly even Robert Graves and Siegfried Sassoon) stand to attention on a passing out parade before marching down to the station on their way to the front. Their camp extended from Moss Lane and School Lane, across Moor Lane (now Church Road) towards the railway on the far side. Through time, Moor Lane has changed from farm track to country road to its present dual carriageway. Just off to the right of the archive photograph, Holy Sepulchre School was replaced later on in the 1930s by English Martyrs church and its school, replaced in its turn by a modern building.

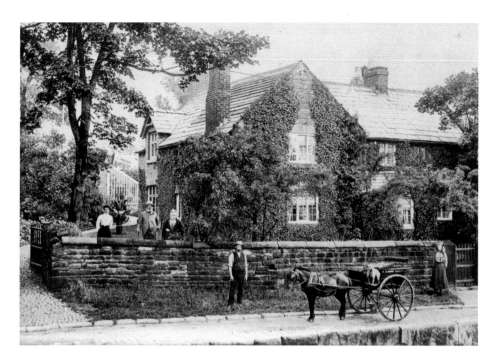

Stonehouse Farm

Even the dog and pony play an important and patient part in the carefully composed scene taken outside Stonehouse Farm, built of stone, of course. Mr Webster JP and family stand proudly in the beautiful garden. Now nothing remains of the farm and farmland along Fields Lane, but Hatton Hill Park is a reminder of the green open space that used to cover much of what we know as Litherland.

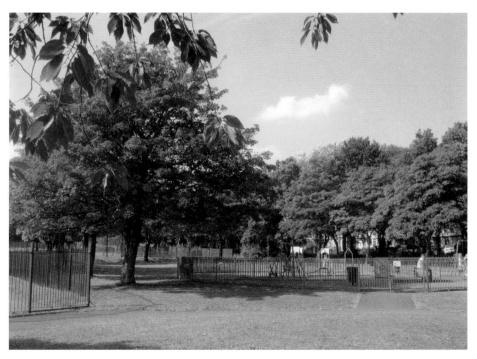

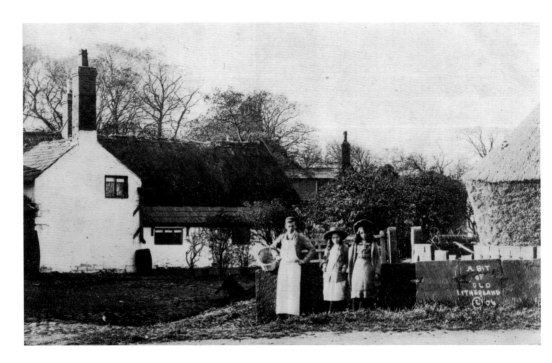

Pickerings Farm

Before the tanneries and factories alongside the canal, there was farmland with thatched cottages, old farmyard equipment, water butts, haystacks and farmyard birds. Fruit or vegetables would be gathered in baskets by boys and girls dressed with hats suitable for the occasion. The rural scene of Pickerings Farm is still preserved along the canal, which supports prolific bird life, although much of the adjacent land has been taken over by housing.

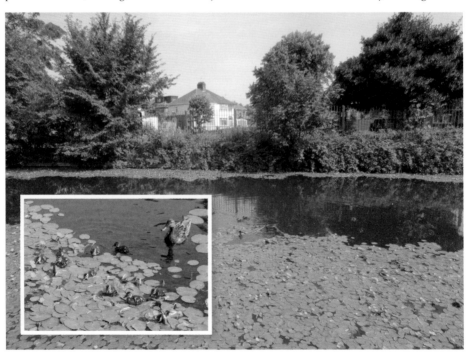